Wildlife
Photographer
of the Year
Portfolio 24

Dear Mr Chetwood,

In animals/nature we catch a glimpse of God's glory, creation and if we look deeper, his love.

My prayer for your family is that the Lord may reveal this love and grace to each of you and that through my imperfections I can still reflect this love to Crystal.

Wishing you all the best, a lovely Christmas and a blessed New Year.

Philip Lemos

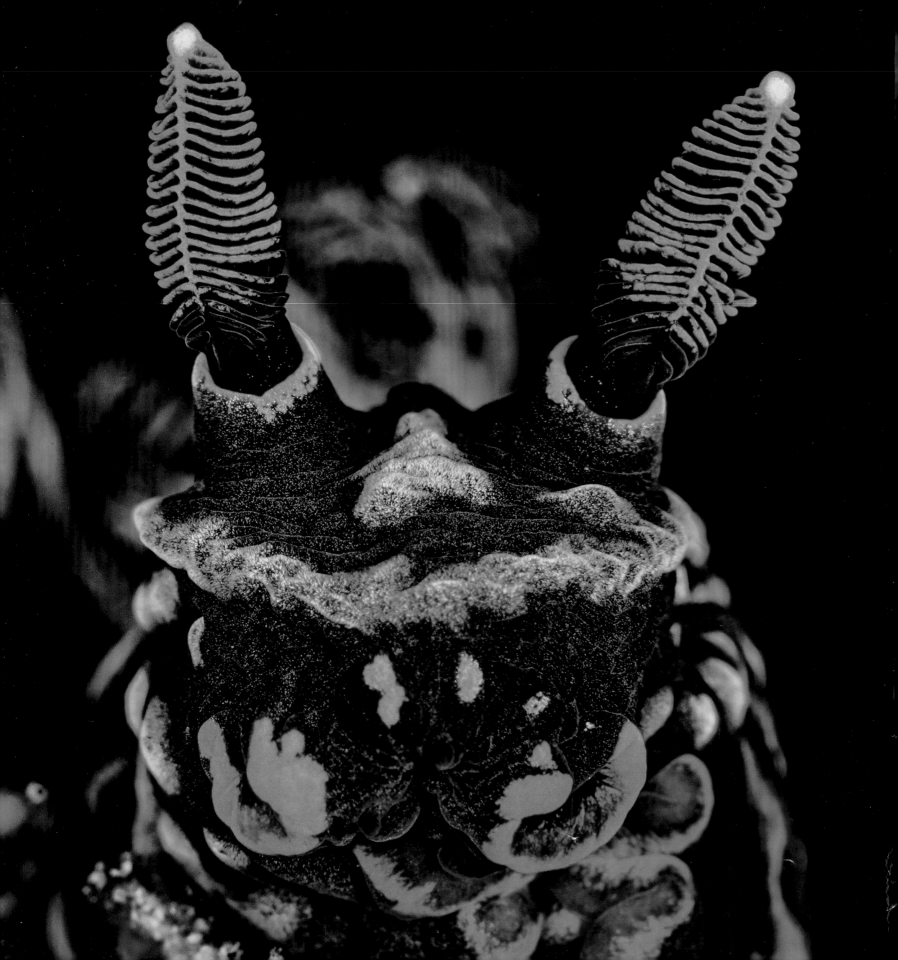

# Wildlife Photographer of the Year

Portfolio 24

Published by the Natural History Museum, London

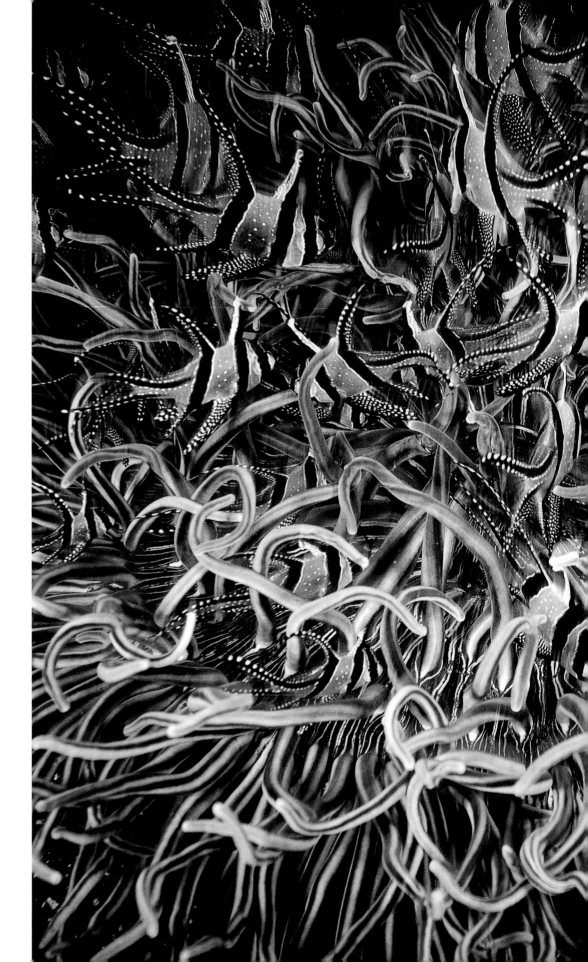

First published by the Natural History Museum,
Cromwell Road, London SW7 5BD
© The Trustees of the Natural History Museum,
London, 2014
Photography © the individual photographers 2014

ISBN  978 0 565 0 93426

A catalogue record for this book is available from the
British Library.

**Editor**: Rosamund Kidman Cox
**Designer**: Bobby Birchall, Bobby&Co Design
**Caption writers**: Tamsin Constable and Jane Wisbey
**Colour reproduction**: Saxon Digital Services UK
**Printing**: Printer Trento Srl, Italy

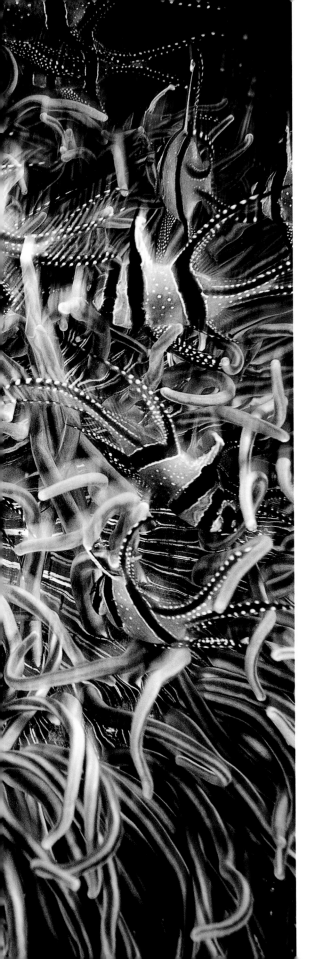

# Contents

# Foreword

The Wildlife Photographer of the Year competition and I have things in common. We both started 50 years ago. I was 18 and gave up a promising career in music, trading my guitar for a camera. Looking back over the past half century gives me some perspective on how much has happened in the world of nature photography, aesthetically and technically, and how the competition has reflected that. You could call us both old-timers. And we both have changed considerably through the years.

I clearly remember one of my early excursions as a boy out onto the prairie with my first tripod-mounted single-lens reflex camera, loaded with a 36-exposure roll of Kodachrome II. I was near tears trying to determine exposure factors with a hand-held meter while using close-up extension bellows. Once the exposure was finally figured out, my exposure times were near impossible with an ISO of 25. The windblown prairie flowers became a hopeless blur, even under the intense and impossible contrast of a bright midday sun.

What a change digital technology has brought to this experience. Now one can use a vibration-stabilized macro or long telephoto lens with auto focus and exposure. An ISO of 2500 (100 times faster), with no limit to the number of images shot and no waiting to see processed film a week or more later, makes it a completely different and virtually effortless technical experience – and all done without having to fiddle around with a clumsy and restricting tripod. Such a seemingly simple change has made a profound difference to the art of composition. Add to that the ability to photograph in the darker but more appealing early and late light of the day, when animals are more active, and it's truly a revolution. The photographer is now able to concentrate more on the aesthetics, as is clearly shown in the work being produced.

With technical hurdles gone, the experience of photographing nature has now almost become a national pastime in many countries. The profession has dramatically changed economically because of this accessibility, but I do believe the world is a better place because of the sharing of special experiences in nature with others – even though my own living has been affected by the increased numbers of great images available for publishing. Sometimes, though, I do worry about the sheer volume of images being produced and consumed, and whether this diminishes their intrinsic value.

In the 50 years since I have been immersed in this craft, I have often observed a near-religious fervour that takes over devotees of nature photography. I can only speak for myself here, but I equate the act of making an exposure of something I care deeply about to a kind of prayer, created in a near trance-like state, and often my finest and most enduring images come from that exquisite moment.

Though I have never spoken of it with another photographer, I feel sure it is not an uncommon experience – all of the fundamental elements are in place for lovers of nature with a creative urge. Certainly worship is a word that could describe feelings some of us have for nature, and so our photographs become offerings – prayer flags.

The camera can then be seen as simply a device that allows one to get closer to the essence of our emotional connection with nature. Culture has generally taught us to subdue that urge. It was indeed the case where I came from. But if you allow that invisible boundary to be broken down, the result can produce powerful imagery – both are prayers and art, important in the human experience. This book contains some of those moments. When taking into account the many precious experiences of the talented creators of these remarkable photographic moments, one may even look on this collection as an intimate journal.

Anthropologists are in agreement that the act of painting the cave walls by our distant ancestors in southern Europe 30,000 years ago was a spiritual ritual meant to express powerful feelings about the natural world around them. It looks to me like not much has changed since then, except the tools.

**JIM BRANDENBURG**
Chair of the judges, Wildlife Photographer of the Year 2014

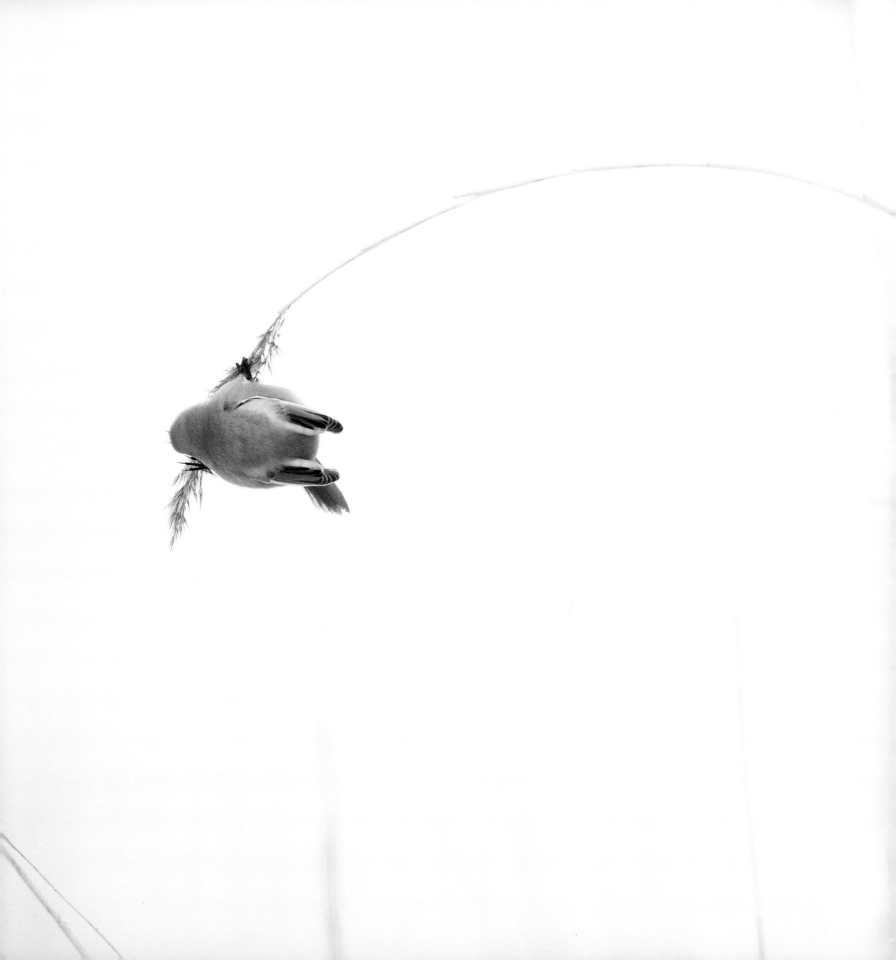

# The Competition

Over the past 50 years this competition has provided both an international showcase for the work of wildlife photographers and charted the development of wildlife photography itself. It remains the world's largest and most prestigious competition championing images of nature and natural environments.

Every year, the competition invites photographers – professional and non-professional, from anywhere in the world – to submit their best images. From thousands of pictures – more than 41,000 from 96 countries this year – an international jury selects 100 images as the premier collection for exhibition and publication. They are seen by many millions of people, not just in this edition of the book and in the opening exhibition in London's Natural History Museum, but also in international editions of the book and galleries worldwide and through the press publicity that follows.

This year's collection marks two milestones: the competition's launch 50 years ago by the forerunner of *BBC Wildlife Magazine* – when colour photography had become affordable and conservation was rising in the public consciousness – and a collaboration spanning three decades between the magazine and the Natural History Museum, a collaboration that has raised the profile of wildlife photography from documentary recording into an art form.

Today we live in a world of moving images, and indeed, the competition now has a time-lapse category. But the emphasis remains on the still image. There is lasting power in the most special of single shots – the ones that you never forget, either through the emotional effect of their aesthetics or because they make you think. The competition uses this power to challenge how we see nature and how we interact with and affect it.

The competition also champions the work of wildlife photographers. It gives them a platform that provides for the full range of natural subject matter and genres of nature photography. Its international reach – together with its range of styles, techniques and ways of seeing the natural world – also serves to inspire a new generation of photographic artists to produce fresh, innovative work.

All pictures are judged first on their aesthetic qualities, though with restrictions on both the manipulation of animals and of the pictures themselves. Wild animals have to be in the wild (except where illustrating an issue in specific categories), and their wellbeing is paramount. No manipulation of photographs is allowed beyond in-camera settings and digital processing according to strict rules. The aim is to make sure that the pictures you see here are truthful reflections of nature and that the artistry is in the original capture.

The judges are also looking for surprises, and not necessarily those that come through new technology but ones that result from fresh observations and new ways of seeing. The result is the hugely varied collection you see here, with an overall winning image that reflects both the classic compositions of the past and the innovations of the present, carrying a message about the future of wildlife and wild places.

The call for entries runs each year from January to February. Find out more at www.wildlifephotographeroftheyear.com

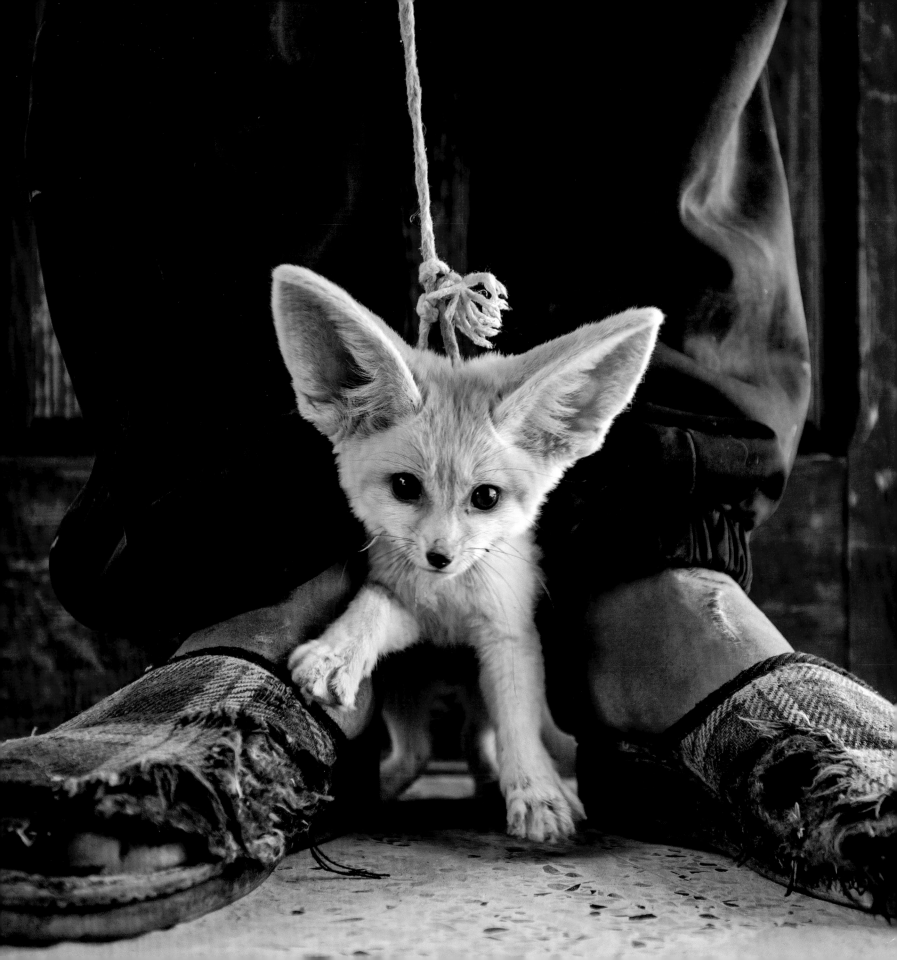

# Organizer

# Magazine Partner

# Judges

Wildlife Photographer of the Year is one of the Museum's most successful and long-running events. Together with *BBC Wildlife Magazine*, the Museum has made it the most prestigious, innovative photographic competition of its kind and an international leader in the artistic representation of the natural world.

The annual exhibition of award-winning images continues to raise the bar of wildlife photography and excite its loyal fans, as well as a growing new audience. People come to the Museum and tour venues across the UK and around the world to see the photographs and gain an insight into the diversity of the natural world – an issue at the heart of our work.

Open to visitors since 1881, the Natural History Museum looks after a world-class collection of more than 80 million specimens. It is also a leading scientific-research institution, with groundbreaking projects in more than 80 countries. About 300 scientists work at the Museum, researching the valuable collection to better understand life on Earth, its ecosystems and the threats it faces.

Last year, more than five million visitors were welcomed through the Museum's doors to enjoy the many galleries and exhibitions that celebrate the beauty and meaning of the natural world, encouraging us to see the environment around us with new eyes.

**Visit www.nhm.ac.uk for what's on at the Museum.**
You can also call +44 (0)20 7942 5000
email information@nhm.ac.uk
or write to us at:
Information Enquiries
Natural History Museum
Cromwell Road
London SW7 5BD

The images that grace the magazine's pages – spectacular, intimate, powerful, thought-provoking and moving – represent the very best of wildlife photography.

*BBC Wildlife Magazine* is proud to have launched the forerunner of this competition in the 1960s and to have nurtured its development into a showcase for the brightest talents in natural-history photography.

The same love of wildlife and wonder at the natural world inspires the magazine.

Every month, *BBC Wildlife Magazine* showcases beautiful images, compelling stories and fascinating facts. Covering everything from animal behaviour to British wildlife, the latest conservation issues to inspirational adventures, our writers are all experts in their fields.

Our award-winning features are illustrated with the world's finest photography – images captured by photographers recognized in this competition.

We publish all of the winning images from the Wildlife Photographer of the Year competition in our glossy and gorgeous guide, free with the November issue.

**Visit www.discoverwildlife.com to subscribe to** *BBC Wildlife Magazine*, read amazing articles and enjoy stunning photo galleries.
You can also call +44 (0)117 927 9009
or email wildlifemagazine@immediate.co.uk

**Tom Ang**
photographer, author and educator
(New Zealand)

**Pål Hermansen**
photographer and author
(Norway)

**Magdalena Herrera**
director of photography *GEO* magazine France
(France)

**Sujong Song**
curator and photography editor
(South Korea)

**Christian Ziegler**
wildlife photographer and tropical ecologist
(Germany)

# Chair of the judges

**Jim Brandenburg**
photographer
(USA)

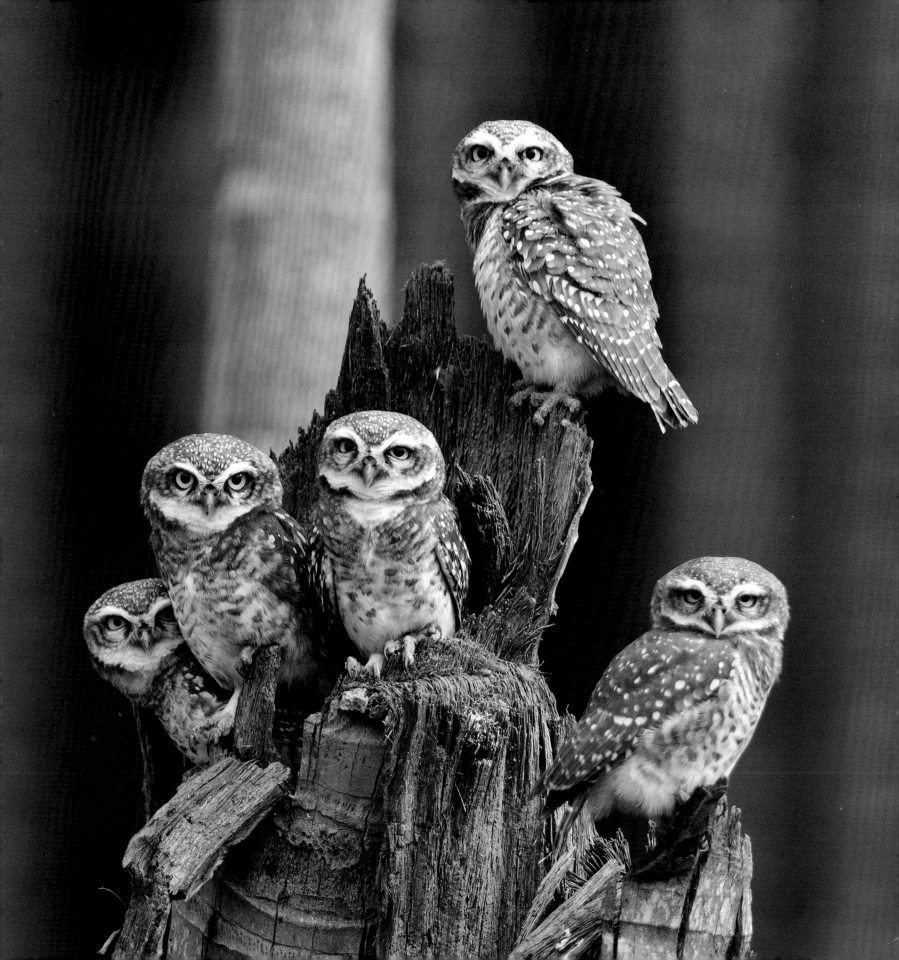

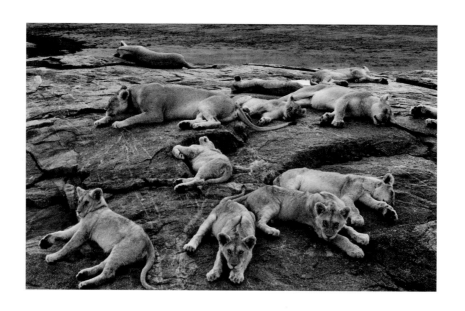

# The Wildlife Photographer of the Year 2014

The Wildlife Photographer of the Year 2014 is **Michael 'Nick' Nichols**, whose picture has been chosen as the most striking and memorable of all the entries in the competition.

## Michael 'Nick' Nichols

Nick is a photographic artist and journalist who uses his skill to tell stories about environmental issues and our relationship with wildlife. His career, much of it with National Geographic, spans more than 35 years, and his work has been published in numerous books and magazines. The mass of accolades he has received reflects the international recognition he has earned. Nick constantly pushes photographic boundaries, making the most of the technology on offer. But for him wildlife photography is not about the gimmicks: 'In a sense it's not about depicting nature – rather it's about messages. If you watch, nature will teach, and I'm an incessant voyeur.' On his lion assignment, he wanted to show these vulnerable predators in their world. 'Lions are headed the same way as tigers and all the other great predators. I know now that photography can effect change – influence legislation, affect fundraising. That's what I hope my coverage might achieve.'

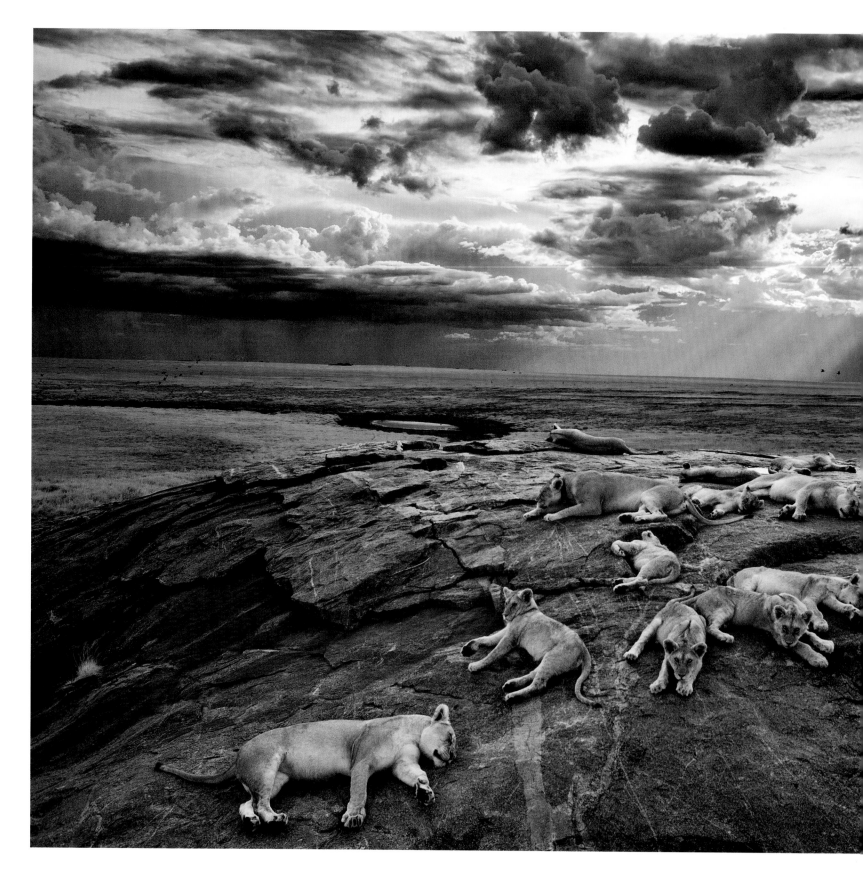

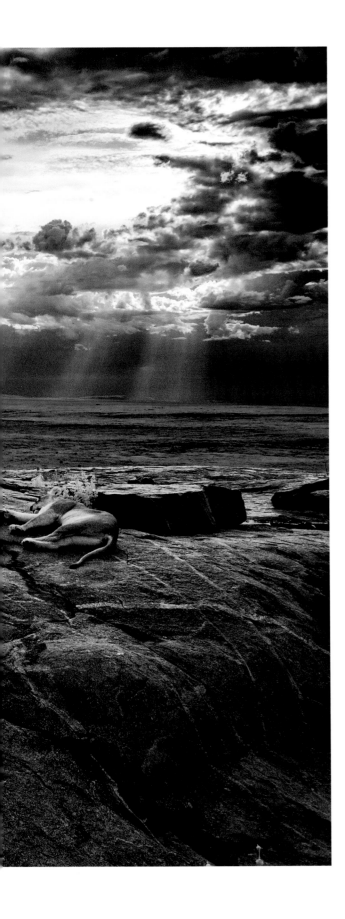

# The Wildlife Photographer of the Year 2014

## The last great picture

### Michael 'Nick' Nichols

USA

Nick set out to create an archetypal image that would express both the essence of lions and how we visualize them – a picture of a time past, before lions were under such threat. Here, the five females of the Vumbi pride – a 'formidable and spectacularly cooperative team' – lie at rest with their cubs on a kopje (a rocky outcrop), in Tanzania's Serengeti National Park. Shortly before he took the shot, they had attacked and driven off one of the two pride males. Now they were lying close together, calmly sleeping. They were used to Nick's presence – he'd been following them for nearly six months – which meant he could position his vehicle close to the kopje. Making use of a specially made hole in the roof, he slowly stood up to frame the vista, with the Serengeti plains beyond and the dramatic late-afternoon sky above. He photographed them in infrared, which he says, 'cuts through the dust and haze, transforms the light and turns the moment into something primal, biblical almost'. The chosen picture – and Nick believes that the creation of a picture is as much in the choice as the taking – speaks about lions in Africa, part flashback, part fantasy. Nick got to know and love the Vumbi pride. A few months later, he heard that it had ventured into land beyond the park and that three females had been killed.

Canon EOS 5D Mark III + 24–70mm f2.8 lens at 32mm; 1/250 sec at f8; ISO 200.

# The Wildlife Photographer of the Year Portfolio Award

## Tim Laman

USA

It was Charles Darwin who first proposed that ornamental traits exist to enhance the bearer's chance of winning a mate and that females mate with the males they consider most attractive. Such appreciation, said Darwin, depends on the female's aesthetic sensibilities. Today, Darwin's conviction that non-human animals might have an aesthetic sense is enjoying a revival. Nowhere in the world is such sexual selection more vividly expressed than among the birds of paradise of New Guinea, Australia and nearby islands. Here geography, geology, climate and ecology conspire to isolate populations and promote the runaway evolution of outrageous ornaments, glorious colours and extravagant displays. This portfolio is just part of Tim Laman's 10-year project to photograph every one of the 39 species of birds of paradise and record their courtship displays, which he undertook with Cornell Lab biologist Ed Scholes.

## Spellbinder

Having whistled his invitation to a female to take her seat, a magnificent riflebird launches into a bewitching performance. He flings his neck back to reveal a breast shield of electric blue that shimmers as it catches the light. Then whipping his head from side to side, he hops up and down on the branch to exaggerate the effect and cracks the air by whirring his wings like sharply flicked fans. There wasn't enough light to freeze the motion, and Tim didn't want to use flash. Instead, he used a relatively slow shutter speed to blur the image. Once a male magnificent riflebird has secured a female's approval and consent, he will drape his wings over and around her, and they will mate under his velvet-black cape.

Canon EOS 5D Mark II + 600mm f4 lens; 1/15 sec at f4; ISO 1250; hide.

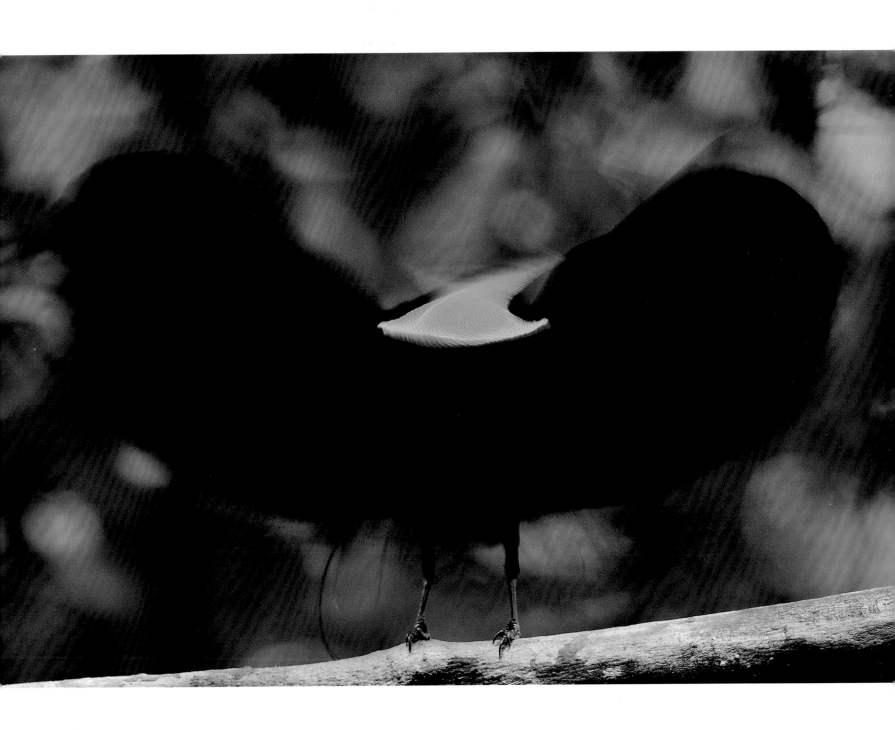

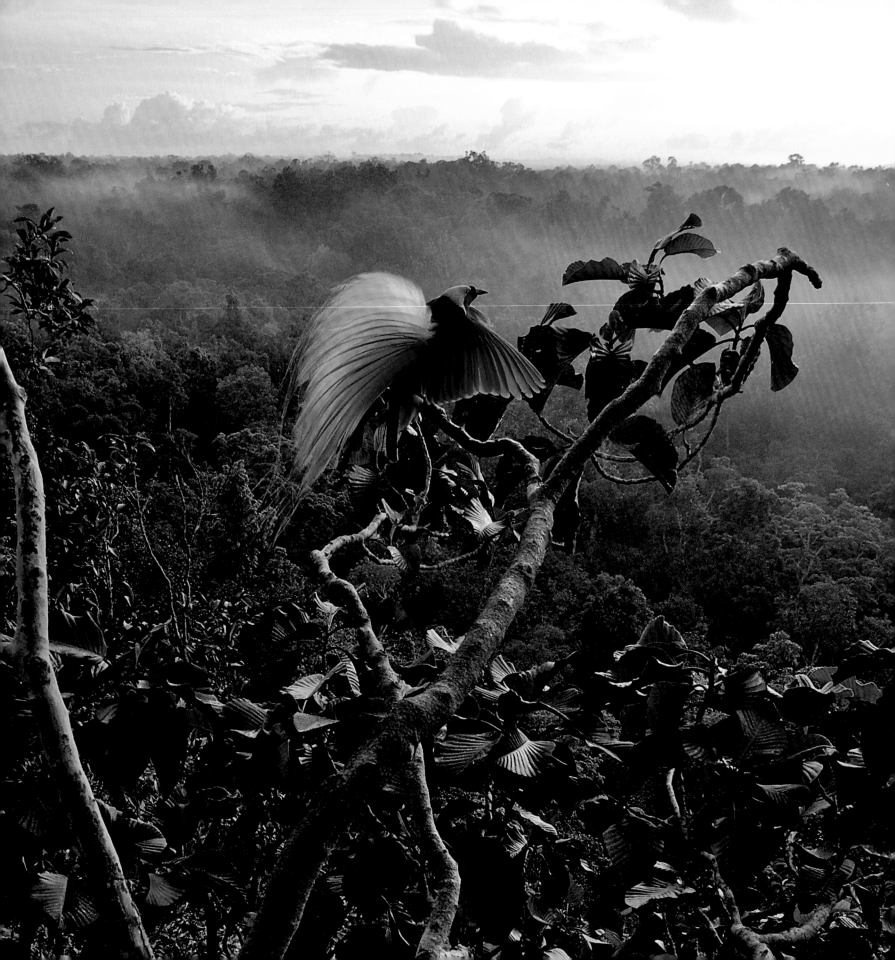

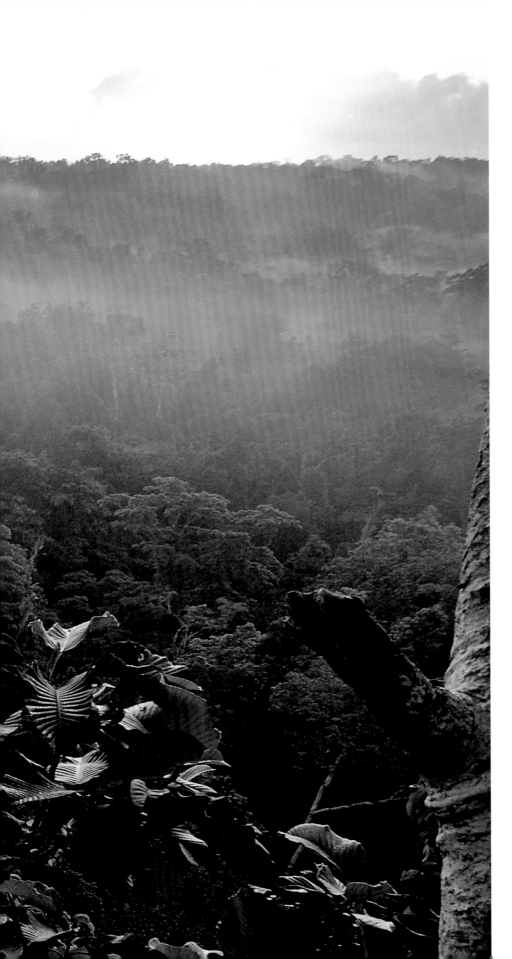

## Sunrise performance

Birds of paradise spend most of their time in the dense rainforest, and so images usually have to be taken with telephoto lenses. But Tim wanted to show a bird performing against the backdrop of the rainforest, which meant a treetop vista and a wide-angle lens. In the rainforest of Wokam Island, in the Aru Islands, Indonesia, he finally found a display tree overlooking the forest where several greater birds of paradise were performing. Climbing into the canopy of a neighbouring tree, he built a leaf-covered hide from where he could watch the action. Then before dawn, he climbed the display tree, mounted his camera (camouflaged with leaves and with a laptop lead strung over to the hide tree) and focused it on where a male was likely to display. From his hide he could then watch and wait, controlling the camera from his laptop. The male was predictable, performing regularly just before dawn and from the same perch. But it was only at this particular sunrise that quite such an amount of mist rose in the distance. As the male paused in his performance, tail and wings fluffed and fanned, Tim managed to create his dream shot and what would be his most treasured picture of the 10-year project.

Canon EOS 7D + 10–22mm f3.5–4.5 lens; 1/125 sec at f8; ISO 400; remote system.

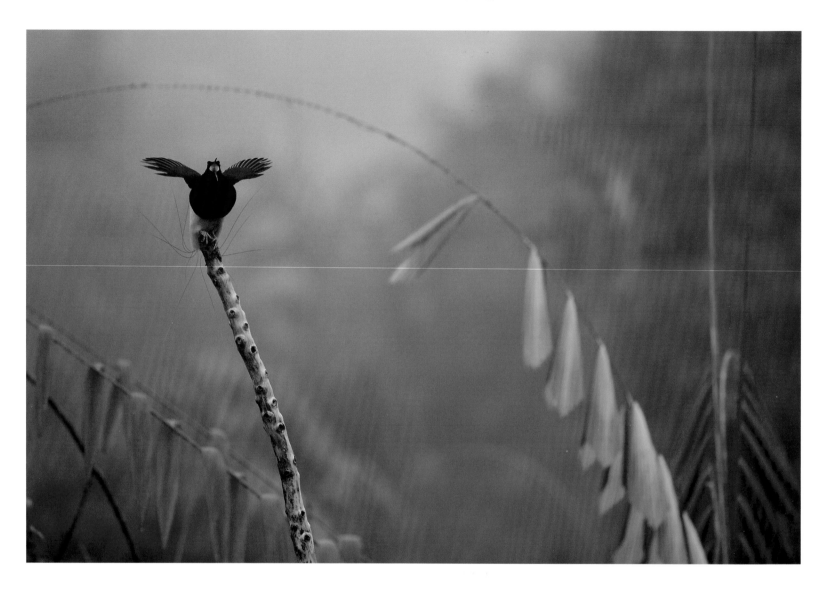

## The pole dancer

In the swamp rainforest of Papua New Guinea, Indonesia, a male twelve-wired bird of paradise poses at first light on his customary display pole and starts his performance. Calling loudly, he reveals the emerald-green inside of his beak, and flares his breast shield. The lack of mammal predators in New Guinea means that displaying is relatively safe for birds of paradise, even for the most trussed up individuals and those displaying on the ground. And forests rich in fruit mean that males have plenty of time and energy to practise and perform. Plentiful food also means the females have no need of the males to rear their young. Historically, the main risk has been humans hunting them for their plumes. Today, the greatest threat is habitat loss: with the forests of Borneo and Sumatra dwindling, loggers are setting their sights on the forests of New Guinea.

**Canon EOS 5D Mark II + 400mm f4 lens; 1/45 sec at f4; ISO 1000; hide.**

## The sensitive mover

Once the male twelve-wired bird of paradise has performed his first display well enough to persuade a female to approach him, he switches to a new tactic. He turns his back on her, twists the lower part of his body from left to right and brushes her face repeatedly with his wire plumes. It's hard to see this gesture in real time, but Tim managed to freeze the moment of contact, showing how displays may comprise touch as well as colour, sound and movement. The female continues to monitor and assess. If the male passes this part of the test, she stays, and he starts tapping her beak with his. Only then does she mate with him. Her choice of partner provides her sons with the same winning looks and habits as their father and her daughters with her own discerning taste in males.

**Canon EOS-1D Mark IV + 600mm f4 lens; 1/180 sec at f5.6; ISO 1600; hide.**

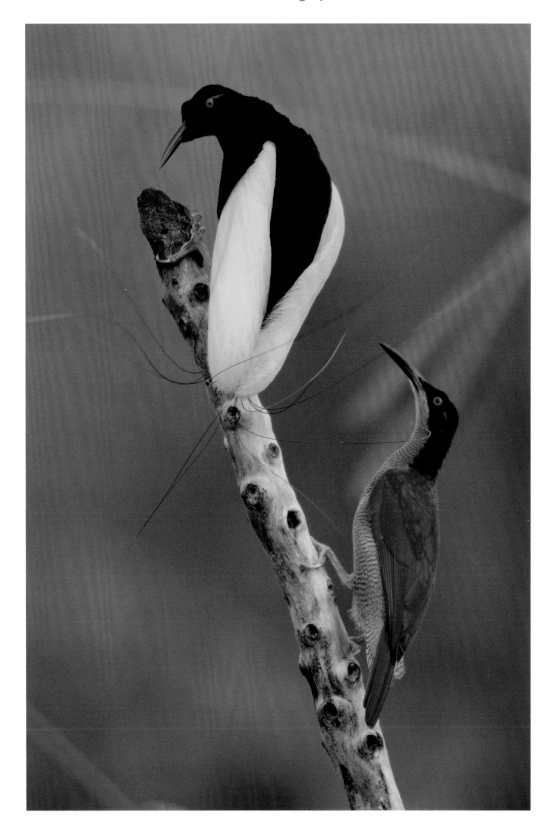

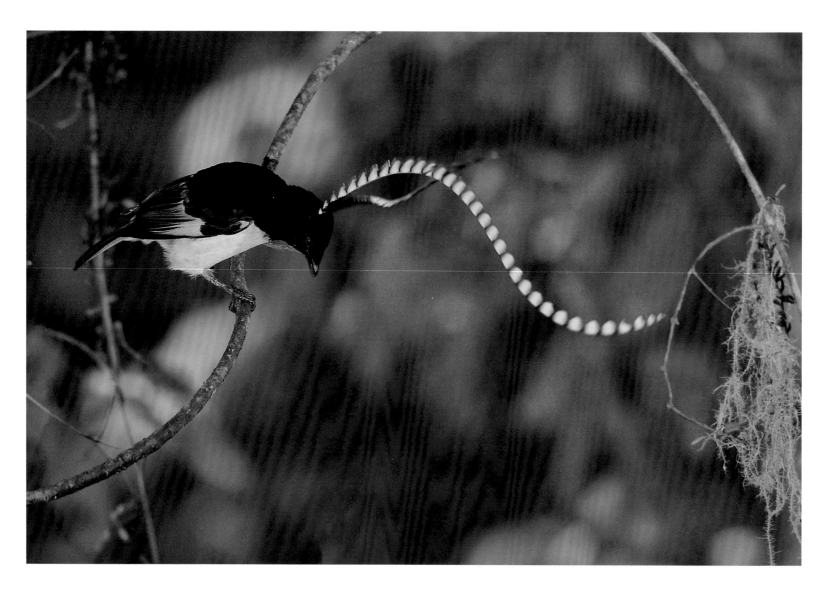

## Banner advertising

The King of Saxony bird of paradise would call all day from high in the canopy. Only very occasionally would it descend to a particular vine to display, and then only for a few seconds. Its small display arena was on the southwestern slopes of Mount Hagen, in Papua New Guinea, and it took a while to find a viewpoint where Tim could both catch him when he emerged and also isolate him against a suitable background of vegetation. The male's head-wire feathers are twice the length of his body and usually lie down his back, but during the display they are flicked forward over his head, at the same time as white tabs are suddenly revealed along their midribs. The bird then pumps his body up and down to set the springy vine bouncing and to create the eye-catching effect of head-wire feathers waving like gleaming banners against the darker understory vegetation.

**Canon EOS-1D Mark II + 600mm f4 lens; 1/180 sec at f5.6; ISO 400; hide.**

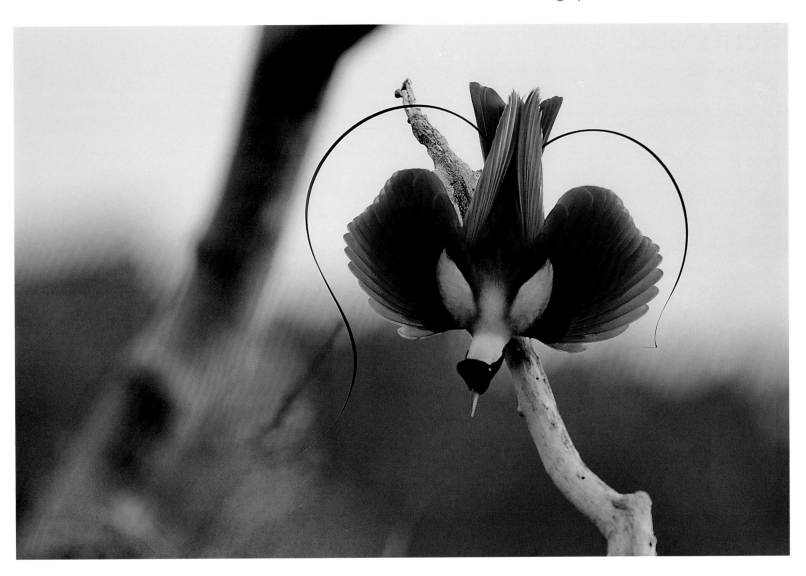

## Heart-stopping show

The sixteenth- and seventeenth-century illustrators of birds of paradise used dead specimens for reference and could never have guessed how fantastically the living birds would use their strange feathers. They certainly couldn't have imagined the choreography of the endangered red bird of paradise. Perched upright, the male dangles his two middle tail feathers alongside his body in a gentle corkscrew shape and flicks them from side to side. Only when he tilts forwards do the ribbons fall gracefully to form a heart-shaped frame for his full quivering display. To capture the pose, Tim built a tiny hide at the top of a 50-metre (160-foot) tree on Batanta Island, Raja Ampat Islands, West Papua, opposite the male's display tree. Every morning he would climb the tree in the dark, ready for the male's romantic moves to begin at sunrise and to try to catch the perfect pose.

**Canon EOS-1D Mark II + 400mm f4 lens; 1/750 sec at f4; ISO 400; hide.**

# Plants and Fungi

## Glimpse of the underworld
### Christian Vizl

MEXICO

Water lilies stretch up to the light through a layer of green mist in the Aktun Ha cenote – a huge sinkhole in Mexico's Yucatán Peninsula. It is one of a great ring of thousands of cenotes (created where the limestone bedrock has collapsed to expose the subterranean groundwater), which Christian has been photographing for the past 10 years. What makes Aktun Ha special is its underwater garden. The water is crystal clear, except in summer, when an algal bloom several metres thick can develop beneath the surface. Christian settled on the bottom of the cenote to compose a picture of this still, silent underworld garden. The challenge was to balance the artificial and the natural light. The intensity and angle of the strobe illumination had to be just right, so as not to overexpose the skittish silvery fish, while bringing out the texture of the leaves, flushed pink through ageing, and without detracting from the natural light filtering down through the algae. The result is a picture that conjures up a sense of why the ancient Maya considered cenotes to be sacred places and water lilies plants of the underworld.

Canon EOS 5D Mark II + 15mm lens; 1/160 sec at f14; ISO 200; 2 x Inon Z-240 strobes.

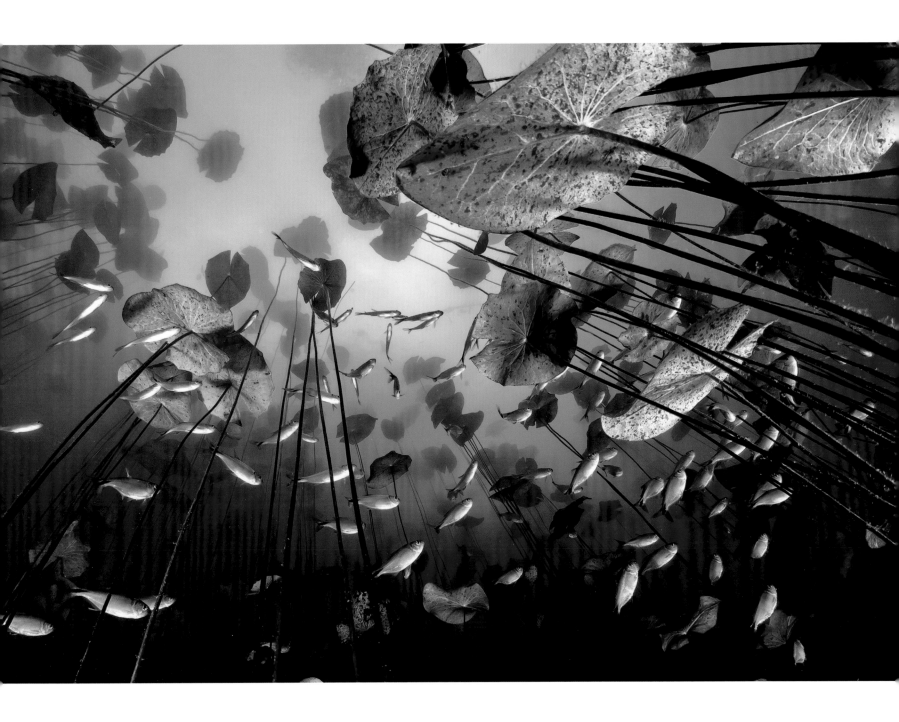

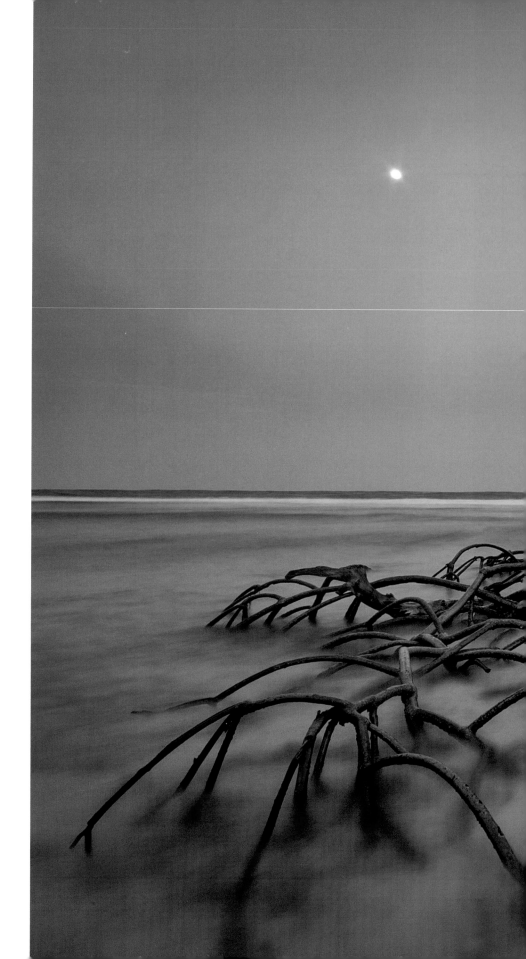

# Beach guardian
## Mac Stone
USA

Of all mangrove species, the red mangrove grows closest to the sea, with prop roots that can withstand tidal waves and submersion in salt water. The thickets of roots shelter many marine animals and also help protect the coast, dissipating the energy of storm waves. In 1998, Hurricane Mitch demolished most of the older mangroves of Pig Keys off the Caribbean coast of Honduras. Mac discovered this survivor while exploring the area. For him, 'it not only symbolizes the beauty of this coast but also the strength and endurance of the people who live there.' Thwarted photographically by bad weather, Mac made the difficult trip again a few months later. 'You need permission, a boat to cross choppy open ocean and plenty of gear – there is no running water or electricity.' At dusk, with the full moon rising, Mac had his chance. 'I wanted the tree to stand out, especially the roots,' he explains, 'and so I used a polarizing filter to cut glare, a wide-angle lens to exaggerate the arches and a long exposure to smooth the water.' The next day, a great storm came through, forcing him to leave once more.

Canon EOS 30D + 10–22mm f3.5–4.5 lens at 10mm + polarizing filter; 3.2 sec at f16 (+0.3 e/v); ISO 100; Manfrotto tripod + Really Right Stuff ballhead.

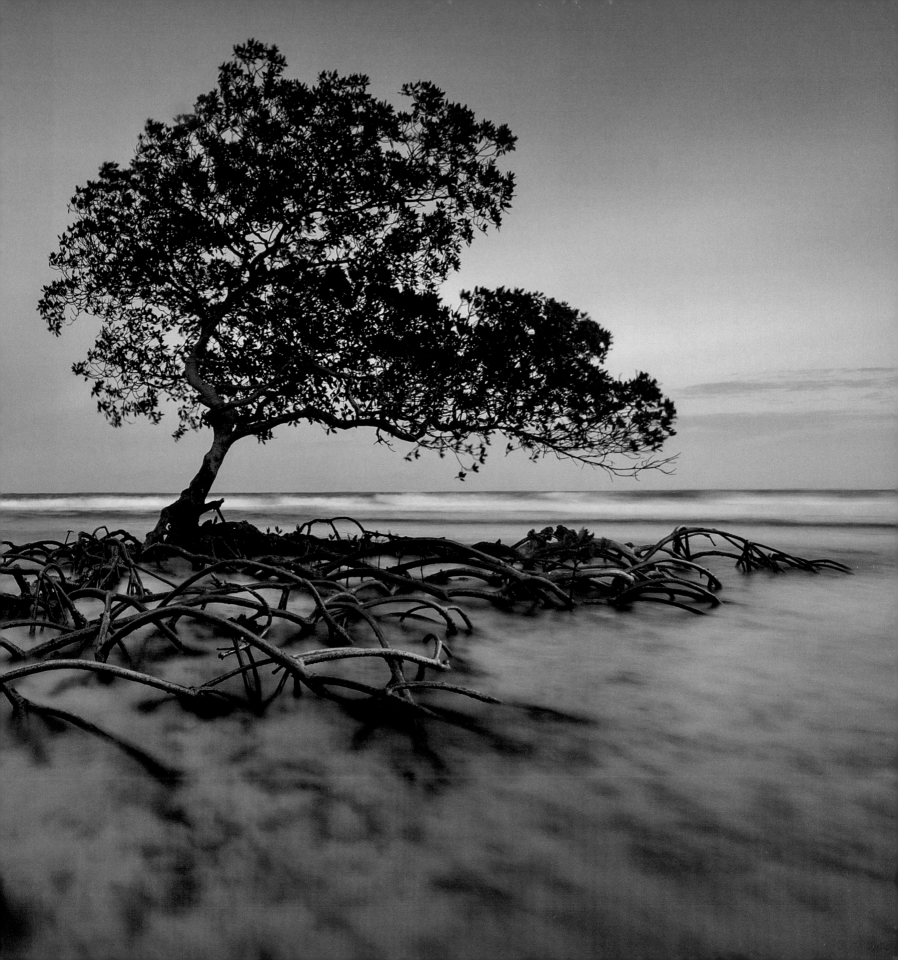

# Snow stand
## Silvio Tavolaro
ITALY

On a freezing winter's day, Silvio was driving home across Monte Livata, Lazio, in the heart of Italy, when a stand of beeches caught his eye. It had just stopped snowing, and the branches of the trees were delicately edged in white. He stopped the car to take in the atmosphere and beauty of the scene. In summer, the beech-leaf canopy blocks out the sun, preventing all but the most shade-tolerant species from growing beneath, but for now, snow had found its way through to carpet the woodland floor. 'I was struck by the silence and wanted to convey the sense of peace and lightness.' Resting his camera on the car door and adjusting the exposure to bring out the contrast between the snow-clad branches and the trunks in the darkness below, he captured the stillness of the moment, before continuing on his way.

Canon EOS 5D Mark III + Sigma 70–200mm f2.8 lens at 70mm; 1/640 sec at f8; ISO 800.

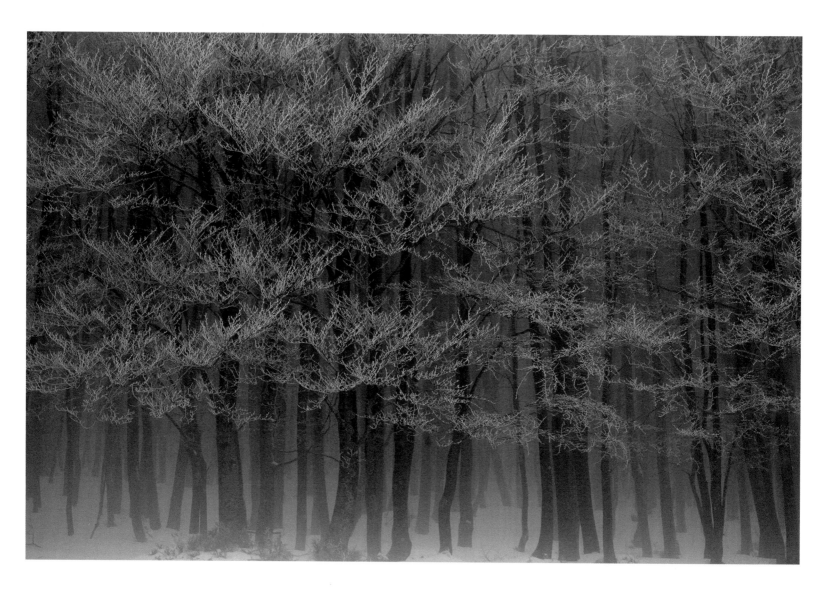

## Natural harmony
Minghui Yuan

CHINA

After heavy rain, the sky began to brighten. Minghui was on the outskirts of Wuhan City in Hubei Province, China, a place with frequent passers-by and many wild plants. Admiring the twisting wild vines in the late-afternoon autumn light, the coiled tendrils began to remind him of treble clefs on a musical stave. As the vines dripped, he sensed a connection between the beauty and sounds of nature and those of music, a source of inspiration to him. 'I like to take pictures wearing headphones, listening to music,' he explains, 'and these symbols sparked my imagination.' He chose a wide aperture to blur the background and isolate the forms, while keeping the coils in focus. Less easy to control was the lighting, as the sun's rays came and went through gaps in the branches. 'I took about 100 photographs before I was satisfied I had achieved my goal – an impression of music, the natural elements combined in perfect harmony.'

**Nikon D3s + Tamron 90mm f2.8 lens; 1/640 sec at f4.5; ISO 400.**

# Golden birch
## Herfried Marek
AUSTRIA

When Herfried woke one October morning and looked out of the window of
his home in Wörschach, Austria, he was taken by surprise at the transformation.
Everything was covered with a thin blanket of white. Heading straight out
'to capture some of the magic' with his camera, he found a favourite silver birch
glowing through a dusting of fresh snow. The green and gold diamond-shaped
leaves were delicately edged with frost, and the pattern of leaves cascading
down the slender, snow-covered twigs, was offset by the graphic nature of the
trunk, its silvery-white bark fissured with age and encrusted with lichen and algae.
Framing and reframing, he finally settled on a composition, the ethereal quality
of the picture enhanced by the white backdrop of freezing fog.

**Nikon D4 + 28–300mm f3.5–5.6 lens at 200mm; 1/200 sec at f14 (+0.6 e/v); ISO 400.**

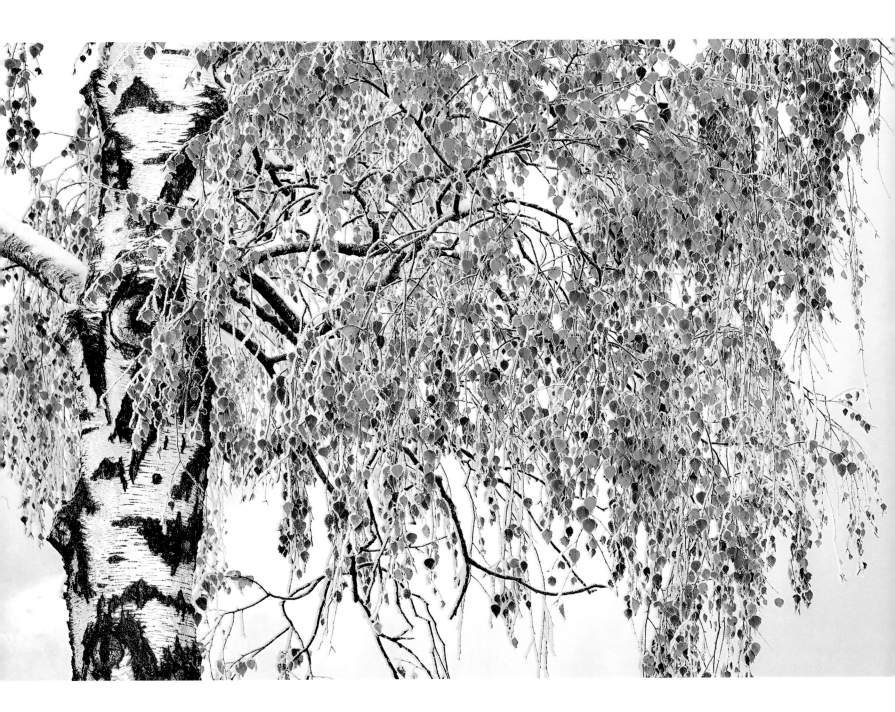

# Black and White

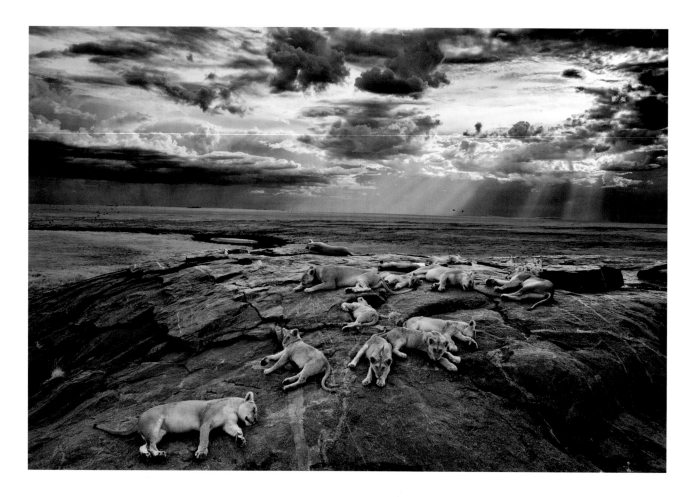

## The last great picture
### Michael 'Nick' Nichols

USA

It's an image of peace and relaxation – the Vumbi pride, females and their cubs laid out on the kopje, overlooking their Serengeti kingdom. It was a key image from a photographic essay about the pride, in a sense, a last look at lions – now under severe pressure. 'The beauty of still photography', says Nick, 'is it can take a moment and turn it into something much more' – in this case, both just another day in the life of the pride but also classic Africa and the end of an era.

**Canon EOS 5D Mark III + 24–70mm f2.8 lens at 32mm; 1/250 sec at f8; ISO 200.**

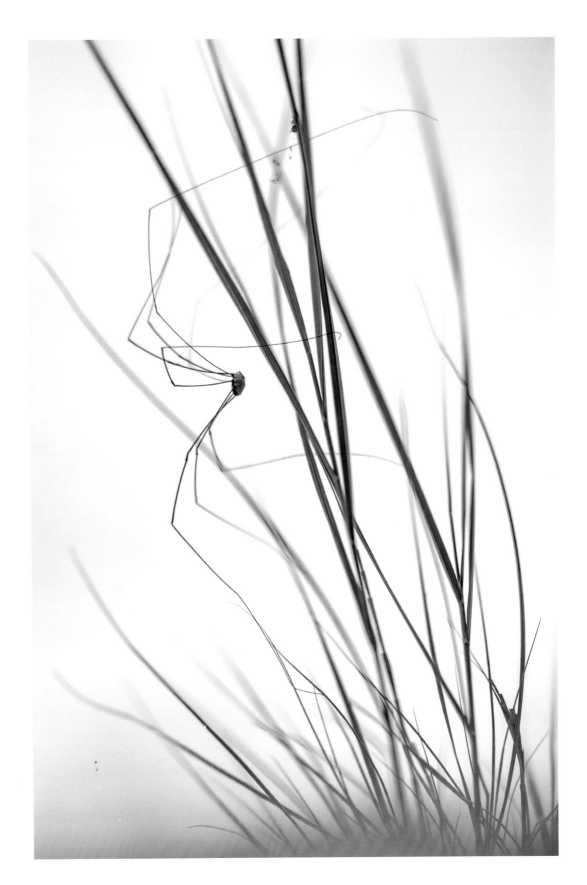

## A long line in legs
### Cristiana Damiano

ITALY

One summer, Cristiana went on a hike
in the Friulian Dolomites Natural Park in
northeast Italy. The ascent was difficult
in places. 'Scrambling over large boulders,
under the hot July sun was hard work with
all my equipment,' recalls Cristiana. She
had stopped for a break in the shade, when
she spotted this delicate harvestman, also
avoiding the heat. 'I was fascinated by
its elegance and camouflage,' she says.
Harvestmen are not spiders but belong to
a different, ancient group of arachnids –
the Opiliones. They are active at night,
walking raised up on their characteristically
long legs, which can be self-amputated
if they are in mortal danger. By day, they
usually cluster in damp, shady surroundings.
'I found it fun to try to bring out the beauty
of an animal so small and common,' she
explains. Later she converted the image to
black and white to emphasize the creature's
exquisite legs, echoed by the grass stems.

**Canon EOS 5D Mark II + 300mm f4 lens;
1/640 sec at f4; ISO 100.**

# Ray rhythm
## Pedro Carrillo

SPAIN

Pedro travelled to Cabo Pulmo National Park
specifically to witness the congregations of
thousands of mobula rays that, each winter,
gather off the east coast of Mexico's Baja
California Peninsula. 'I wanted to raise
awareness of these impressive creatures,
which are increasingly being targeted by
fishermen,' says Pedro. His plan was to
photograph them under water while diving,
but while snorkelling during a surface break,
he spotted an opportunity for a different
composition. Though visibility was poor –
20 metres (65 feet) of murky water lay
between Pedro at the surface and the rays
swimming close to the bottom – from
above the spectacle was impressive and
a perfect black and white composition.
The 400 or more individuals, the largest
school Pedro had ever seen, were moving
with balletic choreography. 'To me this is
a photograph about rhythm,' he explains,
'the synchronous opening and closing of
the rays' wings, their dark forms contrasting
with the delicately textured white sand.'

**Nikon D4 + 14–24mm f2.8 lens at 15mm;**
**1/90 sec at f8; ISO 1600; Seacam housing.**

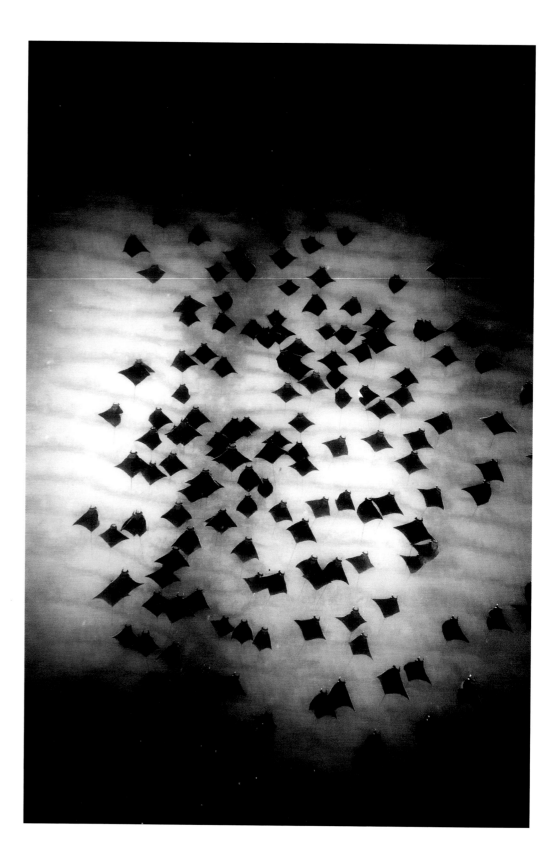

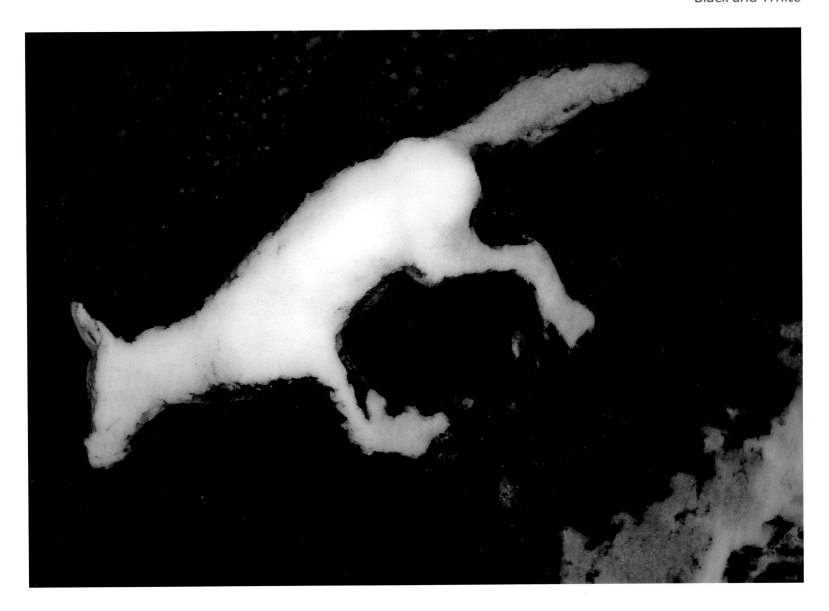

## Snow shroud

### Gavin Leane

IRELAND

Walking along the Dublin coast in February, Gavin came across a dead fox. 'It seemed to have died naturally,' he says, a rare sight in this built-up area, where it is more usual to see roadkill. 'I took some shots and admired its beauty, before returning home.' Later that night, it snowed. Hoping for a different kind of image, Gavin retraced his steps the next day. 'The fox was newly shaped with a shroud of snow,' he says. 'I found it gorgeous – so peaceful – but also reflecting the coldness of death and the vulnerability of the wild.' Gavin framed his shot with a 50mm lens, beloved of portrait photographers and ideal for low-light, and converted the picture to black and white, to concentrate on the bare essentials and mood of the scene.

**Canon EOS 5D + 50mm f1.4 lens; 1/1600 sec at f1.4; ISO 125.**

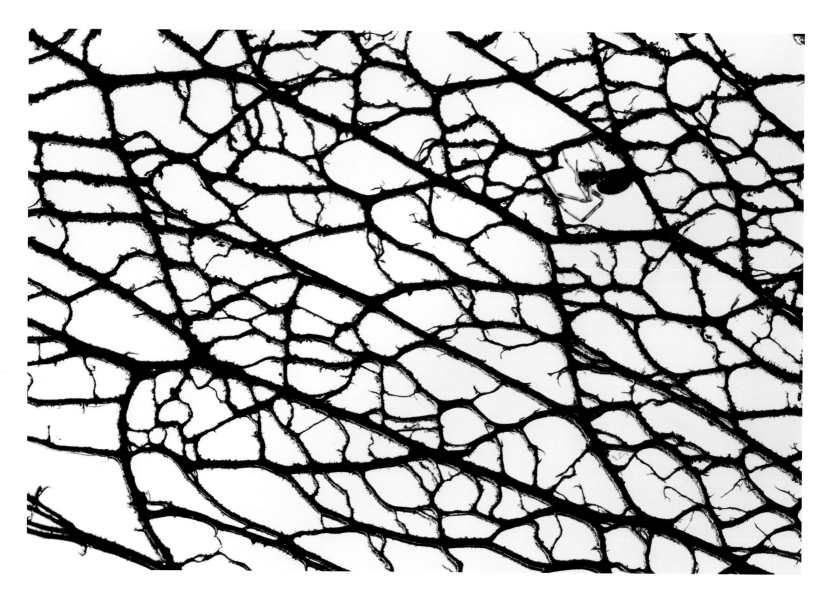

## Spider in the frame
### Juan Jesus Gonzalez Ahumada

SPAIN

From the moment he saw the prickly pear leaf skeleton, Juan wanted to photograph it. Spotting a small spider – less than a centimetre across – hiding in a gap in the dried framework gave him the focal point. Conditions were good. It was a mild January day, and the prickly pear was on a sunny slope on farmland in Andalusia, Spain. But the skeleton leaf was in the midst of other vegetation. So to isolate it, Juan positioned a sheet of white card behind the leaf, taking great care not to disturb the spider, and then composed his image. He shot it in black and white so that nothing would distract from the shapes and texture.

**Canon EOS 7D + 100mm f2.8 lens; 1/250 sec at f7.1; ISO 100; Manfrotto tripod.**

# The elegant crowd
## Jasper Doest
THE NETHERLANDS

When Jasper saw the demoiselle cranes of Khichan in a BBC documentary, he was captivated – both 'by the mass chaos of the vast gathering and their elegance'. Some years ago, the villagers of Khichan, in Rajasthan, India, started putting grain out for the few dozen birds that stopped over on migration from their breeding grounds in Eurasia. Now thousands visit and winter in the region. At dawn, Jasper would join crane conservationist Sevaram Malli Parihar on the roof of his house overlooking a large enclosure erected to protect feeding cranes from stray dogs. 'Rows of Vs would come from every direction, the birds descending into the dunes. Once one had entered the enclosure, others would follow. Soon, it was filled with a sea of cranes, turning their heads in synchrony.' To emphasize the size and dynamics of the flock, Jasper converted the image to black and white – 'to limit the information to just what was necessary'.

Canon EOS-1D X + 400mm f2.8 lens; 1/250 sec at f22; ISO 1000; Gitzo tripod.

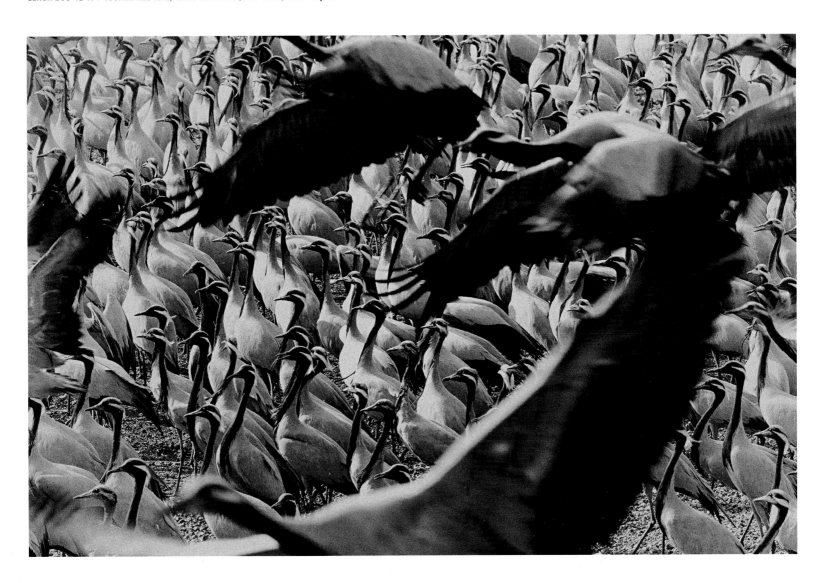

# Mammals

## The mouse, the moon and the mosquito
### Alexander Badyaev
RUSSIA/USA

Something was afoot in the neighbourhood. A giant puffball had started to inflate. Squirrels, chipmunks and mice were compelled to explore the novelty that had appeared in their territories. Eventually the bright white surface of the mushroom was covered with hundreds of tiny prints. Alex, who walked every day along this trail in the Blackfoot Valley, western Montana, USA, noticed that the puffball was becoming a major social centre, particularly once enough individuals had scent-marked it. The puffball and the moon both reached their full size at the same time, which is when Alex returned to the spot. Over the next few hours, as the moon rose, he lay on the ground and was entertained by dozens of small animals exploring the puffball. The most frequent visitors were deer mice, which scampered across the puffball, sometimes standing still to check on their world. To avoid disturbing them and to preserve the sense of place, Alex used the moon as his backlighting, relying on a long exposure and a gentle pulse of flash to show the curve of the fungus and to freeze the frantic activity. When one deer mouse paused for a moment to investigate the persistent mosquito, it provided the perfect midnight puffball scene.

**Canon EOS-1D Mark IV + 105mm lens; 2.5 sec at f14; ISO 250; Canon 430EX II flash.**

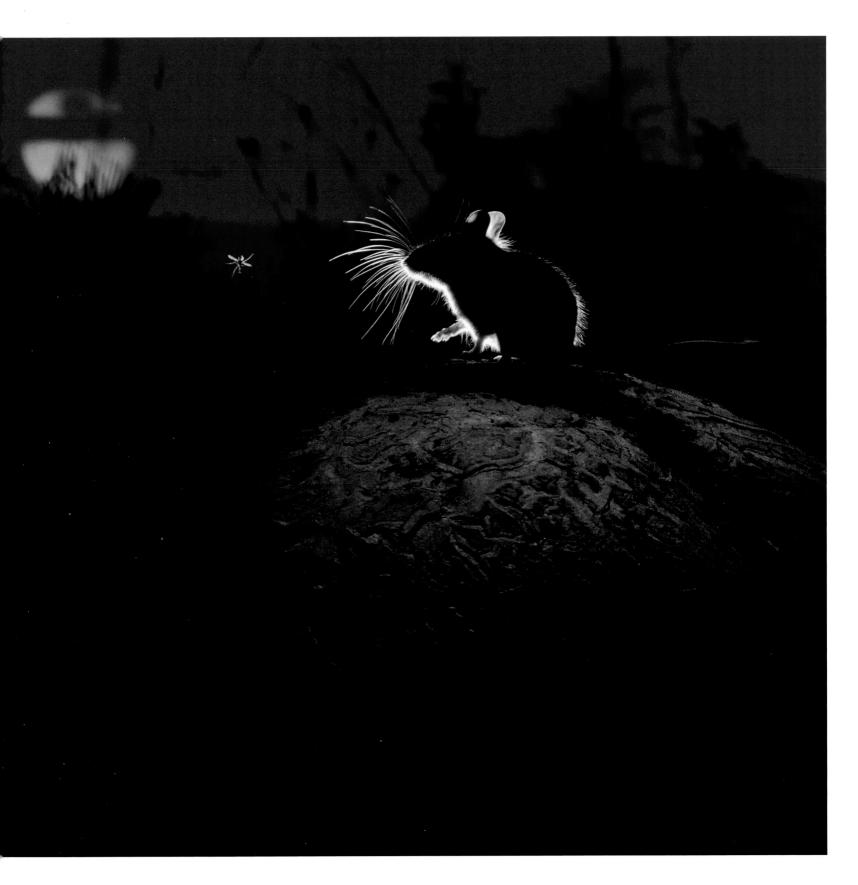

# Intimacy

## Michael 'Nick' Nichols

USA

When all five females of the Vumbi pride, in Tanzania's Serengeti National Park, came into oestrus together, there followed six weeks of almost non-stop mating. It makes sense for a pride's cubs to be born at the same time. There is an element of communal care, they can grow up at the same rate, they can feed on kills at the same time, and they can socialize. But for the pride's two resident males, Hildur and C-Boy, mating 'was an exhausting time', says Nick. 'It was fierce – every seven minutes or so. The females get really twitchy – they don't want to do anything else.' Here C-Boy rests for a moment, though the female is soliciting another mating. There was plenty of light, but Nick had already set up his infrared camera, planning to photograph the consorting pair into the night, not wanting to disturb them by using normal flash. To position the camera at their level, he mounted it on a radio-controlled robot with tank tracks. By shooting in black and white, 'stripping out detail and distilling things to a simplicity', he was able to convey the intimacy of the moment.

Canon EOS 5D Mark III + 24mm f8 lens; 1/180 sec at f8; ISO 200; radio-controlled robot.

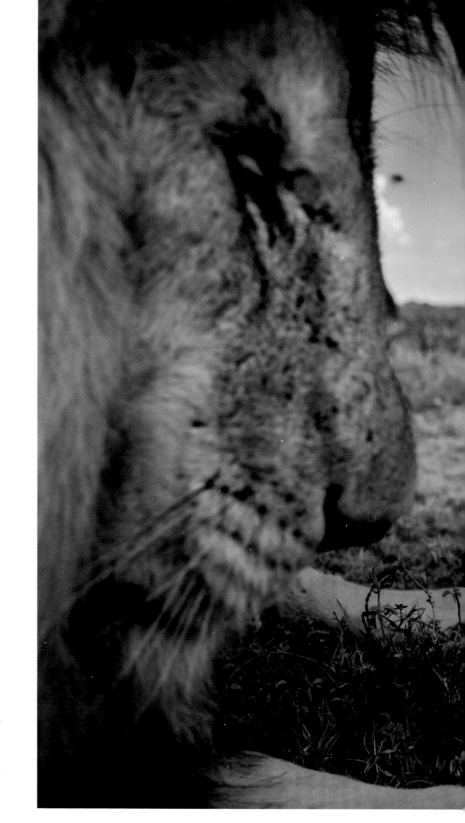

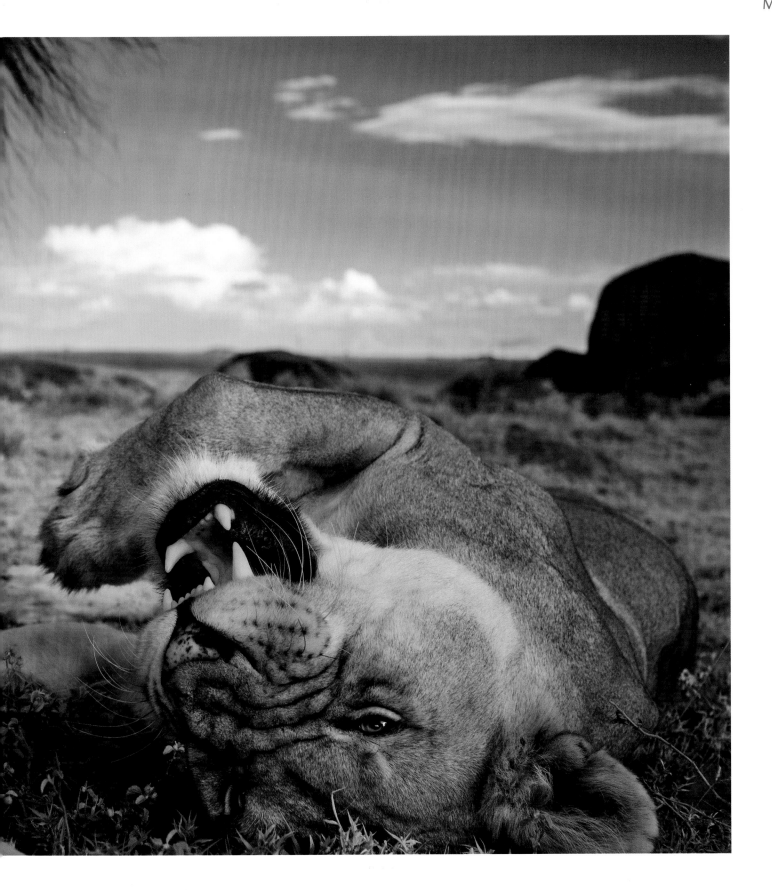

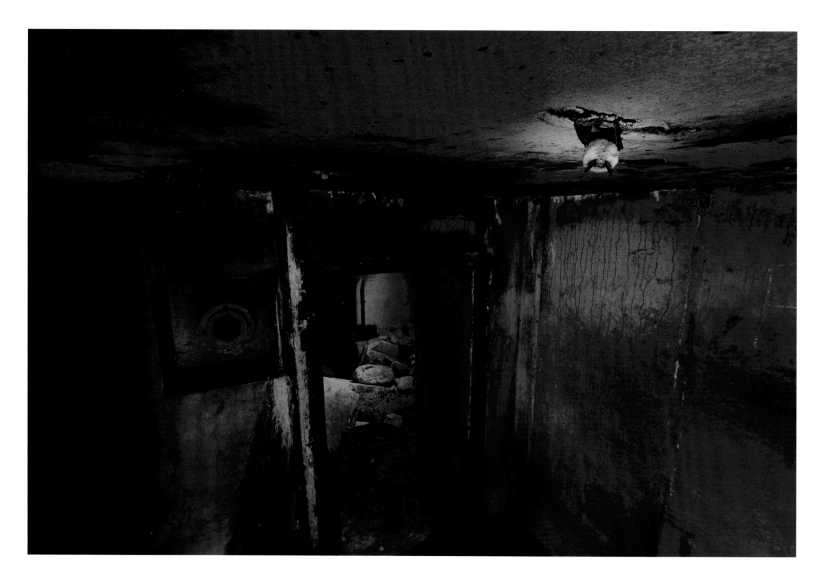

# Winter hang-out

## Łukasz Bożycki

POLAND

It was a freezing January night when Łukasz found the three abandoned bunkers, built by Germans in the Second World War. He was working in the Puszcza Piska Forest, northern Poland, with his friend Piotr Tomasik, studying overwintering bats. For a week, they slept on the floor of an abandoned house. The bunkers were warmer – just above zero – though Łukasz couldn't stop himself shivering. Inside were hibernating Daubenton's bats, in complete torpor (one breath per 90 minutes). To emphasize the eerie atmosphere, Łukasz set his camera to a cool-white balance and used his flashlight to illuminate one bat that was hanging from the ceiling, while Piotr lit the doorway with his light. 'The trek back to the car a distance away in severe cold was a challenge,' says Łukasz, who came down with pneumonia shortly afterwards. Sadly, Piotr later died. This picture is dedicated to him.

**Nikon D7100 + Sigma 10–20mm f3.5 lens at 10mm; 13 sec at f9 (-0.7 e/v); ISO 800; cable shutter release; Manfrotto tripod; two LED flashlights.**

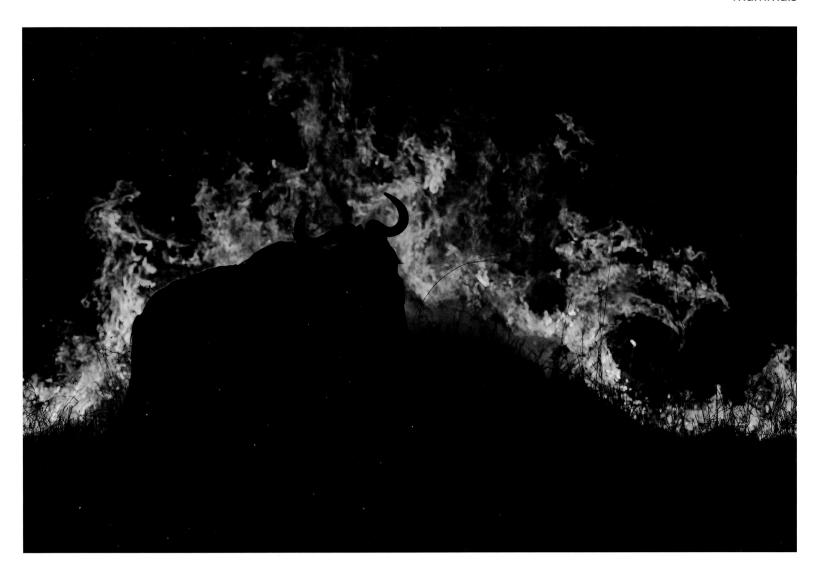

## Fleeing the flames
### Greg du Toit
SOUTH AFRICA

On safari with friends in Tanzania's Serengeti National Park, Greg spotted smoke. It came from a grass fire sweeping across the plain. Driving towards it, he saw a lone wildebeest, seemingly reluctant to move. Its leg was broken. As the blaze approached, he watched in horror. 'It was incredibly hot and smoky, but we stayed, willing the animal to leave.' Finally it did, just as the flames were lapping at its tail. He took the shot as part of a bigger story on wildebeest migration – the annual cycle when around 1.3 million animals move from the Serengeti to the Maasai Mara and back in search of food, water and minerals. Many perish on the way, and not just at river crossings. 'I want to portray some of the challenges they face,' explains Greg. Fires are one of them. Though this individual escaped the flames, its likely fate was falling prey to hyenas or lions.

**Nikon D3s + 80–400mm f4.5–5.6 lens at 175mm; 1/1000 sec at f5.6; ISO 1250; beanbag.**

# The enchanted woodland
## David Lloyd
NEW ZEALAND/UNITED KINGDOM

As the sun slid towards the horizon, the soft, afternoon light transformed the fever trees in Kenya's Nakuru National Park into an enchanted woodland The trees alone were a good enough subject by themselves, says David, 'but I was thrilled to encounter this leopard resting so magnificently on one of the boughs.' He removed the teleconverter on his lens to get a wider view of the scene. The leopard was relaxed, repositioning itself every now and then, but David wanted a pose that was a little more special. He waited, aware that the dappled light was fading fast. He was using a long lens in low light at 1/500 sec with a very high ISO and now relying on his back-up camera – previously untried with this lens – as his first had broken down. At the moment the leopard yawned, he took the shot and captured a classic leopard profile, 'the animal laid out perfectly on the branch'. But to make it truly special, he stitched the image to a second of the other half of the woodland, now touched by the sun's last rays – so 'recreating the magical scene as I would remember it'.

**Nikon D800E + 400mm f2.8 lens; 1/500 sec at f4; ISO 900; beanbag.**

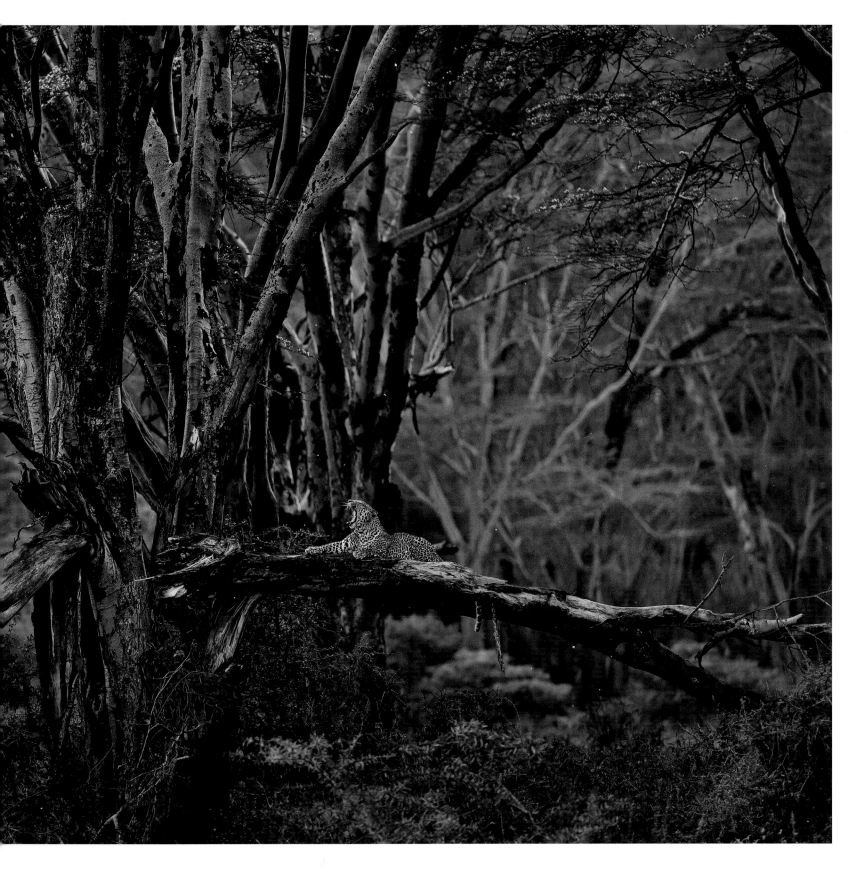

## Communal warmth

Simone Sbaraglia

ITALY

About an hour before sunset, Simone set up at the edge of a cliff, high in the Simien Mountains of Ethiopia, where he knew a group of geladas would return after a day's foraging on nearby grasslands. Geladas are the last surviving species of a once widespread group of grass-grazing primates, now confined to certain spots in the Ethiopian highlands, threatened by the loss of their grasslands and competing with livestock for grazing. The troop arrived on cue, and as the sun set and the cold night loomed, the monkeys disappeared over the cliff to find a safe place to sleep where they could huddle together for warmth. Simone leant over, balancing against a rock to get as close as possible without falling. By now, it was almost completely dark, and so he increased his ISO setting to maximum, used a gentle pulse of flash and focused straight down the cliff, capturing just one graphic composition of these close-knit characters.

**Nikon D800 + 70–200mm f2.8 lens at 180mm; 1/125 sec at f13 (-0.6 e/v); ISO 6400; Nikon SB-800 flash.**

# Creative dining
## Brian Skerry

USA

The extraordinary mud-ring-hunting technique of bottlenose dolphins is known to occur in only two locations: Crystal River and Florida Bay, both in Florida, USA. Brian headed for the bay, hoping to photograph this rare behaviour as part of a project on intelligence. The shallows over the mudflats are rich feeding grounds for the dolphins, which use sonar to locate their prey – mainly mullet – emitting a series of clicks and then listening for the echoes. When a shoal is detected, one dolphin zooms over and circles it, striking the mud with its tail to create a wall of muddy water around the prey. As the wall starts to collapse, the panicking fish leap out of the water towards the rest of the dolphin gang, who line up just outside the ring and athletically snatch the fish from the air. To frame the dolphins in the act – the hunt taking just seconds – was a challenging prospect. Working from a helicopter with a dolphin researcher, Brian captured the moment when the lead dolphin completed a perfectly coiled ring and its two accomplices jumped up, mouths agape, ready to grab a meal.

**Nikon D4 + 500mm lens; 1/1600 sec at f9; ISO 3200.**

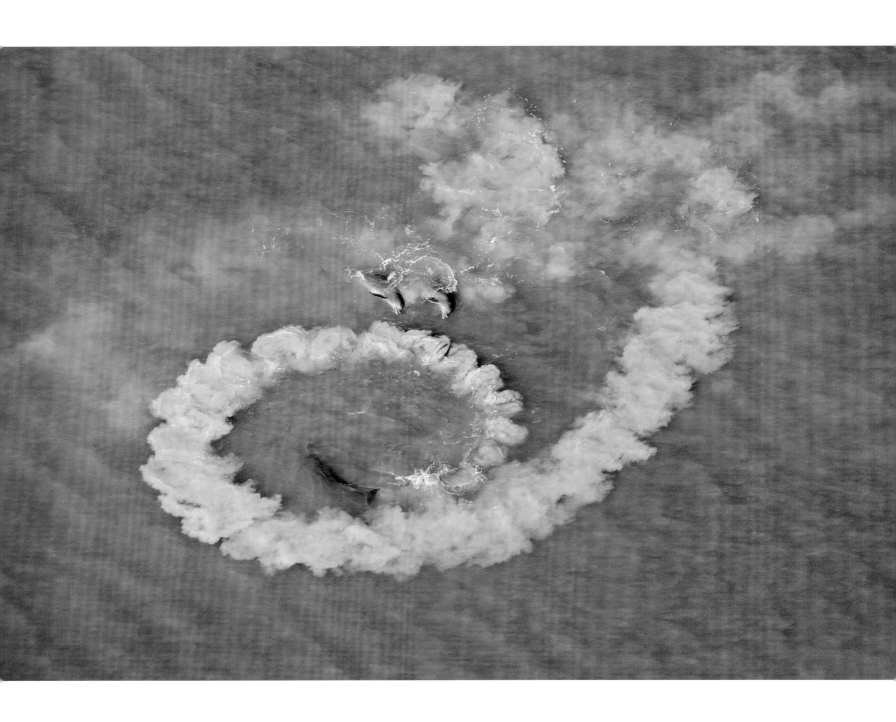

# Invertebrates

## Night of the deadly lights
Ary Bassous

BRAZIL

On warm, windless, humid nights, the old termite mounds on the Cerrado (savanna) of Emas National Park, in central Brazil, sparkle with eerie green lights. It's a mesmerizing scene. The lights are bioluminescent lures flashed by click-beetle larvae that have made their homes in the outer layers of the mounds. When conditions are right, they poke out of their tunnels, shine their 'headlights' and wait for prey – most usually flying termites, which emerge on humid evenings for their aerial mating orgies and then look for new places to colonize. Ary kept the shutter open for 30 seconds to blur the flashes, effectively enabling the beetles to create their own works of art. The result was small pools of intense colour if the larvae remained still, or starbursts if they wriggled. Some adult beetles were also flying, painting their flight paths against the night sky. Other light sources included distant lightning, the orange glow of lights from two towns, glittering stars and the flashlight Ary used to illuminate the termite mound. To photograph the peak of the phenomenon, which occurs after the first wet-season rains and lasts for only a couple of weeks, Ary would stay in the park overnight. Though he suffered occasional 'bouts of crippling fear' at the thought of jaguars and other dangerous animals that might be out after dark, the total experience and the resulting pictures were worth it – in this case, a shot that he had been trying to achieve for nearly a decade.

**Nikon D800 + 16–35mm f4 lens at 16mm; 30 sec at f5.6; ISO 3200; Manfrotto Carbon One 440 tripod + Acratech ballhead; Maglite flashlight.**

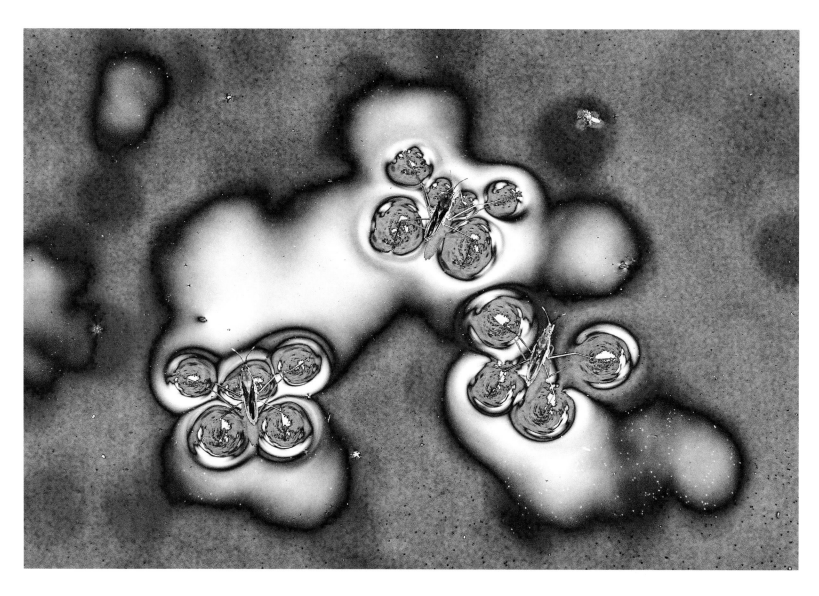

## Skating on sunlight
### Herfried Marek
AUSTRIA

Herfried had set off to photograph grouse in the forest near his home in Styria, Austria. But he ended up being mesmerized by pond skaters. What first caught his eye were the patterns of light on the dark water of the forest pool, but then he started watching the designs created by the pond skaters. Photographing them was not easy: the bugs – less than a centimetre long – were constantly moving, and the changing light in the forest produced a kaleidoscope of patterns. Standing effortlessly on the water, buoyed by surface tension and the water resistance of tiny hairs covering their bodies, they propel themselves by their middle legs, using their hind legs as rudders, as they chase small invertebrates. Hand-holding his camera, Herfried finally managed to frame the moment when three individuals paused close together in pools of reflected sky.

**Nikon D7000 + 28–300mm f3.5–5.6 lens at 300mm; 1/80 sec at f11; ISO 1250.**

# Sailing by
## Matthew Smith
UNITED KINGDOM/AUSTRALIA

In strong winds, thousands of Portuguese men o' war are blown onto the coast of New South Wales, Australia. These are cnidarians – each a floating colony of four kinds of organisms, dependent on one another for survival. Rafts of them trapped in a sheltered bay offered Matt a chance to photograph them. On this attempt – one of many – he was in the water at sunrise, to catch both the eerie light and the clearer water brought in by high tide. A breeze pushed the animals along like tiny sailing boats, making framing tricky, and despite a wetsuit, Matt didn't manage to avoid stings. But the main problem was lighting. Strobes illuminated all the particles in the water, and so he used fibre-optic snoots, pinpointing the light and bringing out the luminosity and beauty of an often unappreciated creature.

**Nikon D300s + 10.5mm f2.8 lens; 1/15 sec at f13; ISO 250; Aquatica housing + 20cm acrylic dome; Inon Z-220 strobe + fibre-optic snoots.**

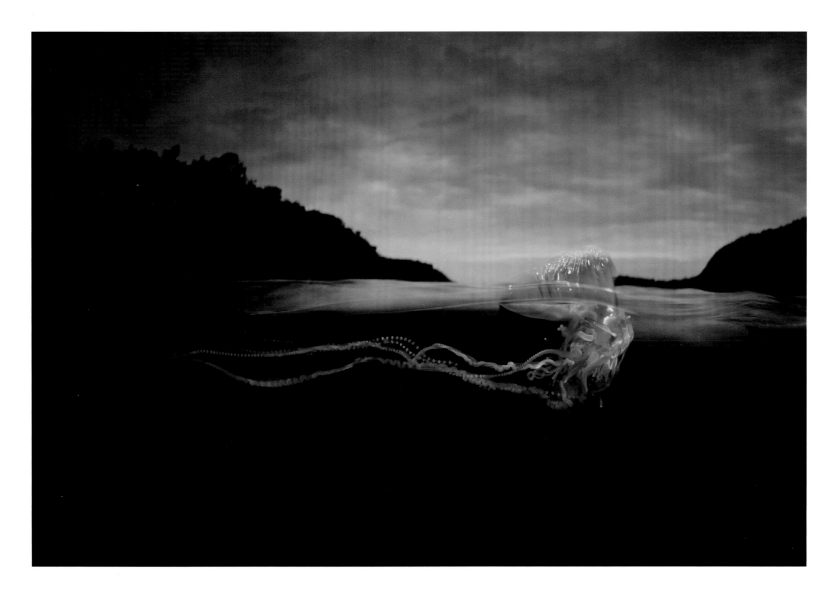

# Firefly fiesta
## Jürgen Freund

GERMANY/AUSTRALIA

The first time Jürgen saw such a magical sight was many years ago, on the banks of a river in the Bicol region of the Philippines. Thousands of fireflies (winged beetles), each with light-emitting organs in their abdomens, had lit up three Indian almond trees as they flashed their presence to potential mates. But the bank was too muddy to set up a tripod for the long exposure needed, and it was impossible to photograph the spectacle from his boat. Many years later, returning to the same province, locals told Jürgen about another almond tree where fireflies gathered, along a much smaller river. Organizing a boat, he set out after nightfall and found the fireflies swarming. This time there was solid ground beside the tree where he could just about stand and set up his tripod without falling into the river. The spectacle was electrifying. Fireflies were flashing in their thousands, some synchronized, some more syncopated, one blink appearing to answer another. Finally, he was able to make the picture he had kept in his mind's eye for such a long time, thankful that the moon was at the right height to silhouette the tree.

**Nikon D3 + 24–85mm f2.8–4 lens at 85mm; 149 sec at f4.5; ISO 800; Manfrotto tripod + Arca Swiss ballhead.**

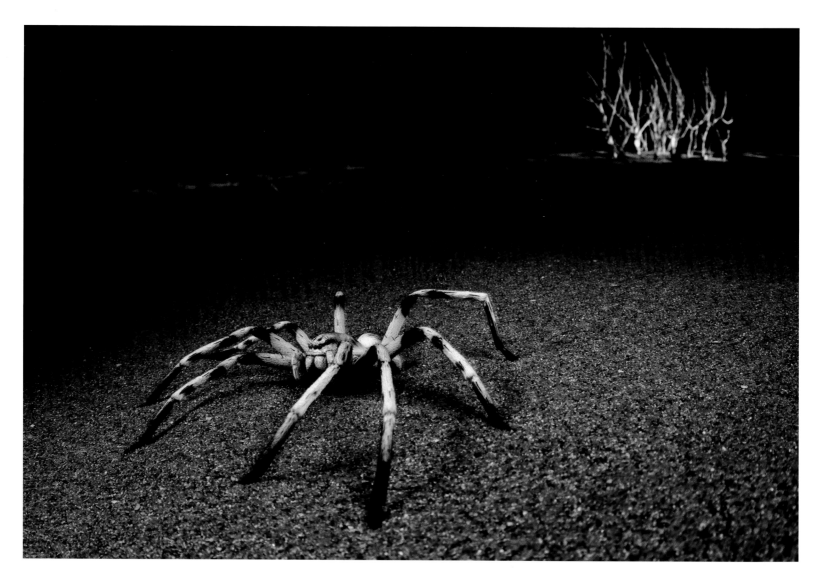

# Night stalker
## Javier Aznar González de Rueda
SPAIN

Exploring the dunes of Oman's Wahiba Sands one night in search of reptiles, Javier came across a xerxes huntsman spider, about 10 centimetres (4 inches) across, out hunting, probably for geckos or invertebrates. Huntsman spiders have relatively poor vision but an excellent sense of vibration. 'This one was fast and didn't hesitate to defend itself, jumping right onto my boot,' says Javier, who couldn't resist getting his camera out. 'I wanted to show the habitat that it lives in' – not so easy in the dark, with a fast-moving subject and sand blowing all around. Highlighting the background with a flashlight, he quickly set up his camera and wide-angle lens. At first, the spider raised its legs defensively, but then it calmed down, allowing Javier to take a low-level shot of the hunter in its environment.

**Canon EOS 600D + Sigma 15mm f2.8 lens; 15 sec at f20; ISO 200; two Yongnuo flashes; Fenix flashlight; Manfrotto tripod + ballhead.**

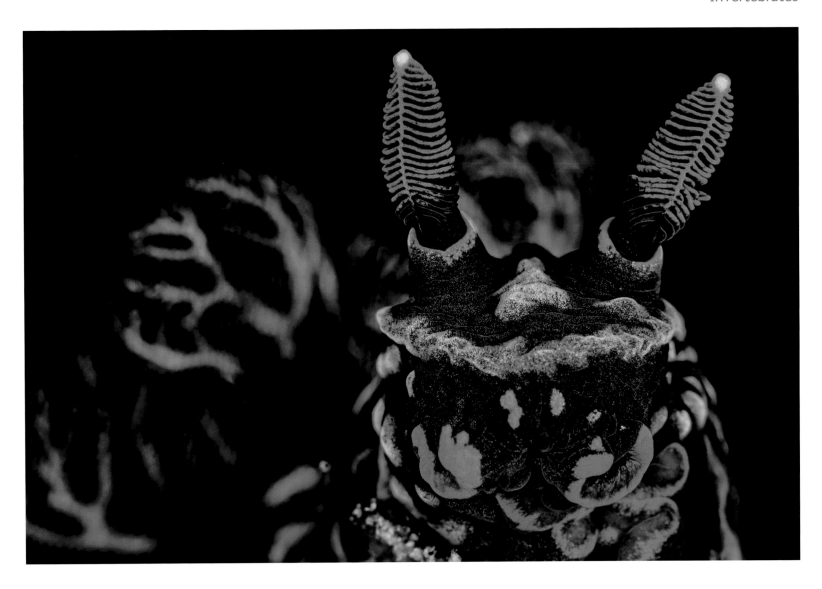

## You have been warned

### Alex Mustard

UNITED KINGDOM

When Alex went diving in the Lembeh Strait in North Sulawesi, he was on a mission to celebrate the smaller sea creatures. Equipped with a new high-magnification lens, he encountered this variable neon nudibranch (sea slug) crawling across the seabed. Less than 2 centimetres (an inch) long, with green gills on its back and orange mouthparts, it has orange, feather-like rhinophores that it uses to 'smell' out its prey – sea squirts. It incorporates distasteful chemicals from the sea squirts' skin into a slimy mucus and uses neon colours to warn predators that it tastes bad. Alex wanted an eye-level view of this unforgettable mollusc. But even with a small aperture, it was a challenge: there was little depth of field (amount in focus) and the subject was moving – and a slug's pace under magnification is surprisingly fast.

**Nikon D4 + 105mm f2.8 lens + Nauticam Super Macro Converter; 1/250 sec at f40; ISO 200; Subal ND4 housing; two Inon Z-240 strobes.**

# Amphibians and Reptiles

## Divine snake
### Raviprakash S S
INDIA

In the monsoon season, green vine snakes often venture near houses, in this case just a few metres away from Raviprakash's front door, in Karnataka, in the heart of the Western Ghats. They are attracted by the many lizards and frogs that shelter among the vegetables and flowers in his garden. Only in the past two or three years, he says, has he 'mastered the skill of identifying them amid a mass of green'. This snake had transformed into a plant and was even swaying in the breeze. 'A vine snake tends to spend a considerable amount of time in the same location,' says Raviprakash, and 'it will wait for prey with divine concentration,' freezing in position once it has its prey in sight. The main challenge was to show the snake from this unusual perspective, and without disturbing its concentration. For Raviprakash, 'the green vine snake is one of the most beautiful creatures I have ever seen. Each time I photograph one, it looks ever more beautiful.'

**Nikon D5000 + 85mm lens; 1/400 sec at f6.3; ISO 200.**

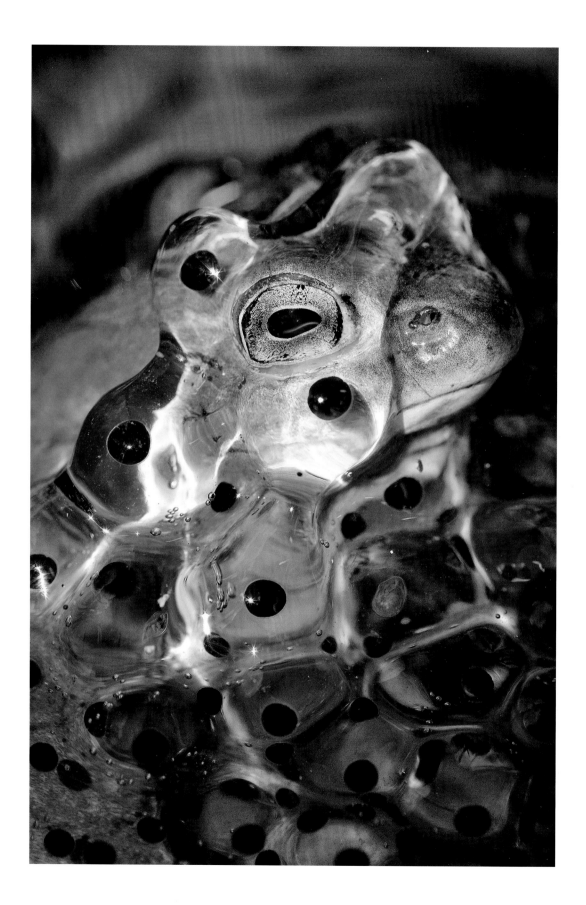

# Eye of the spawn
## Ewald Neffe
AUSTRIA

When hundreds of moor frogs arrived at their spawning pond in Burgau, Austria, Ewald's home town, it was time for him to pull on his waders. The males – the most visible on top of the females – had turned from dull brown to intense blue, and the water boiled with the mass of mating and egg-laying couples. Ewald slowly inched towards them until he was standing waist-deep in the freezing water and then started to compose his shots. Through his viewfinder he suddenly became aware that one of the eggs had been transformed into an eye and appeared to be staring at him. Gradually the frog raised his head above the surface, still wrapped in spawn, and paused for his portrait.

**Nikon D300 + Sigma 150mm f2.8 lens; 1/500 sec at f6.3; ISO 250.**

## Transparent care
### Ingo Arndt
GERMANY

A beam of sunlight shines down through a leaf and through the translucent skin of a tiny male reticulated glass frog clinging to its underside. He is guarding a clutch of maturing eggs, stuck to each other and to the leaf with jelly, and he will guard them for two weeks, until the tadpoles hatch and drop into the stream below. Males will wrestle other males in defence of their patches and in their attempts to attract females to their spawning leaves. They will also fend off predatory wasps intent on taking the eggs. The behaviour of glass frogs and their transparency have always fascinated Ingo and inspired his trip to Costa Rica in search of them. Transparency is the perfect camouflage, but Ingo managed to find a number of brooding males clinging to leaves beside a small stream in the Piedras Blancas National Park, some guarding several clutches, and with the aid of a ladder, he got his shots.

**Canon EOS-1Ds Mark III + 100mm f2.8 lens; 1/45 sec at f11; ISO 250; Gitzo tripod.**

# Big daddy

## Yukihiro Fukuda

JAPAN

It took Yukihiro six years to get this shot of a male Japanese giant salamander guarding eggs in his den. This mighty amphibian – up to 1.5 metres (5 feet) long – is unique to Japan, inhabiting fast-flowing streams and rivers. It is a national symbol, the stuff of legends and protected as a Special Natural Monument – but its natural behaviour has seldom been photographed. Hunting a variety of small prey by night and hiding under rocks and in crevices by day, giant salamanders are extremely difficult to locate. Finding one in a spawning burrow is even harder, but that was what Yukihiro set out to do as part of his project to illustrate the giant's ecology. Spawning takes place in late August. The males compete, sometimes viciously, for the best spawning sites – burrows, holes or just pits in the sand that they may hold on to for many years – where the females will lay their 400–500 eggs, joined like strings of beads. The male nest-holder will then look after the eggs until they hatch in mid-October and then guard the larvae until early spring. As soon as spawning began in the Hino River in southwest Japan, Yukihiro went diving every day – up to 10 hours a day – in search of the action. The most difficult thing was finding a spawning burrow, but he finally got his portrait of the father in his hiding place, soon after the female had left him with the clutch.

**Canon EOS 60D + 8–15mm f4 lens; 1/125 sec at f10; ISO 800; Inon S-2000 strobe; Inon underwater blimp.**

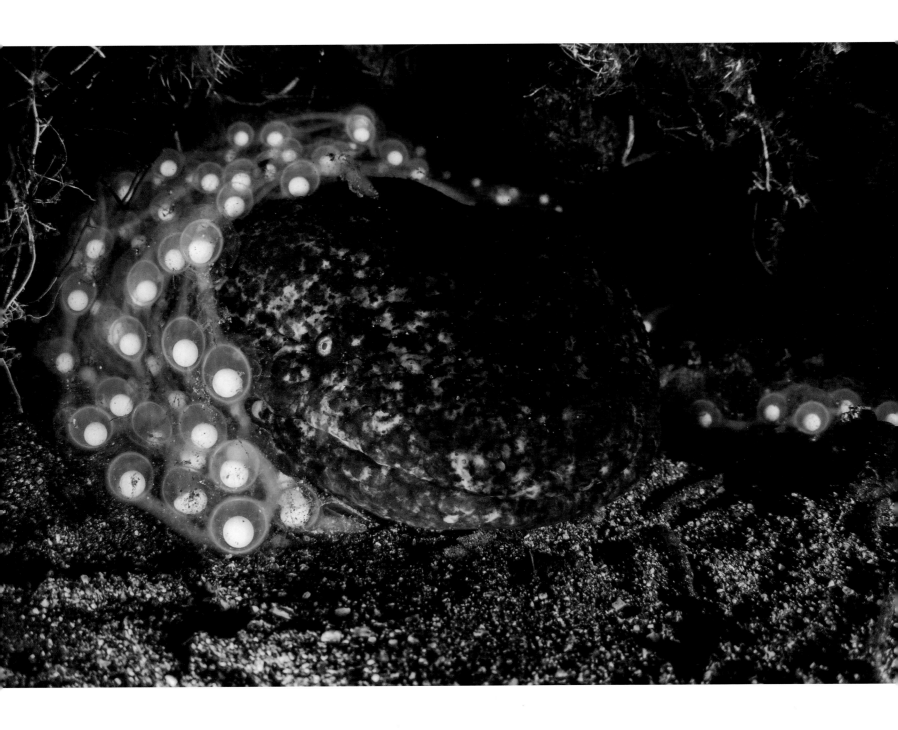

# Spikes and stars
## Hannes Lochner

SOUTH AFRICA

The Kalahari Desert is a hot, harsh place, but the creatures that live there are experts at making the most of every opportunity. Hannes was based in the desert part of the Kgalagadi Transfrontier Park, South Africa. It had drizzled the night before, bringing out a host of insects and, in turn, geckos looking for a meal. The Bibron's thick-toed geckos became acrobats, running, jumping and leaping from bush to bush to catch insects. 'They would run across our tent roofs, leaping up to grab a meal mid-air.' After one such leap, this individual landed on a tumbleweed (the dried, detached and seed-dispersing part of the plant, blown along by the wind) glowing in the light of the campfire. Gambling on capturing the Milky Way as a backdrop, Hannes risked a long exposure, using soft flash to freeze the gecko as it paused, and managed to capture both the spiky reptile, the spiky seedpods and the stars.

**Nikon D3s + 16mm f2.8 lens; 73 sec at f4; ISO 3200; Speedlight Kit R1C1; Benbo tripod.**

# The great arrival
## Sergio Pucci
COSTA RICA

The mass nesting, or arribada, of hundreds of thousands of olive ridley turtles occurs along Costa Rica's Ostional National Wildlife Refuge once or twice a year. The endangered turtles arrive from their feeding grounds to mate offshore, and the females then haul themselves up the beach to lay their eggs. Sergio witnessed his first arribada when he was 10, and over the years has photographed the spectacle many times but until now, never from the air. Its timing is unpredictable, and it usually peaks at night. For five years Sergio tried to get his dream aerial shot, taking off in the dark in an ultra-light autogyro, to be overhead at first light. 'The day I made this photo, we found the beach empty but the ocean packed with turtles.' Returning that afternoon, he finally had his chance, focusing on the pattern of their tracks on the wet sand as a way of representing the multitude.

**Nikon D800 + 24–70mm f2.8 lens at 70mm; 1/320 sec at f3.5; ISO 800.**

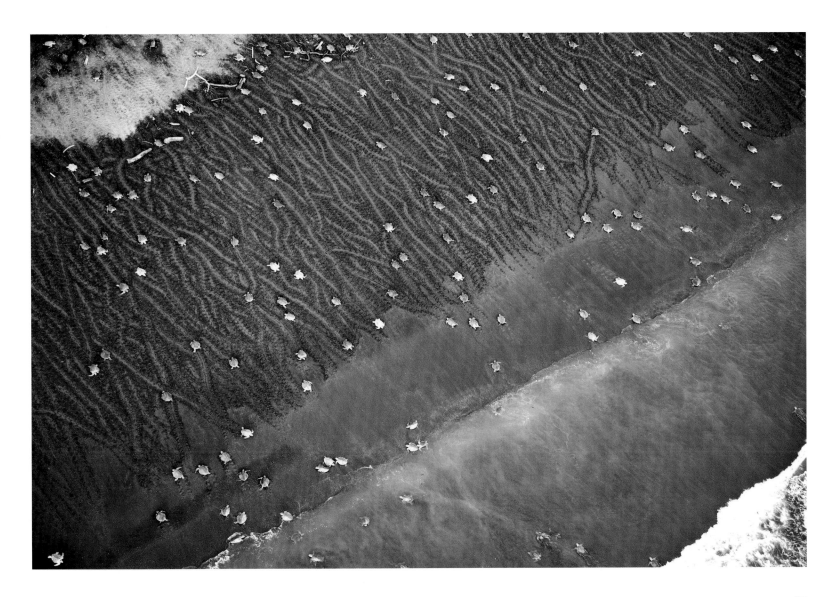

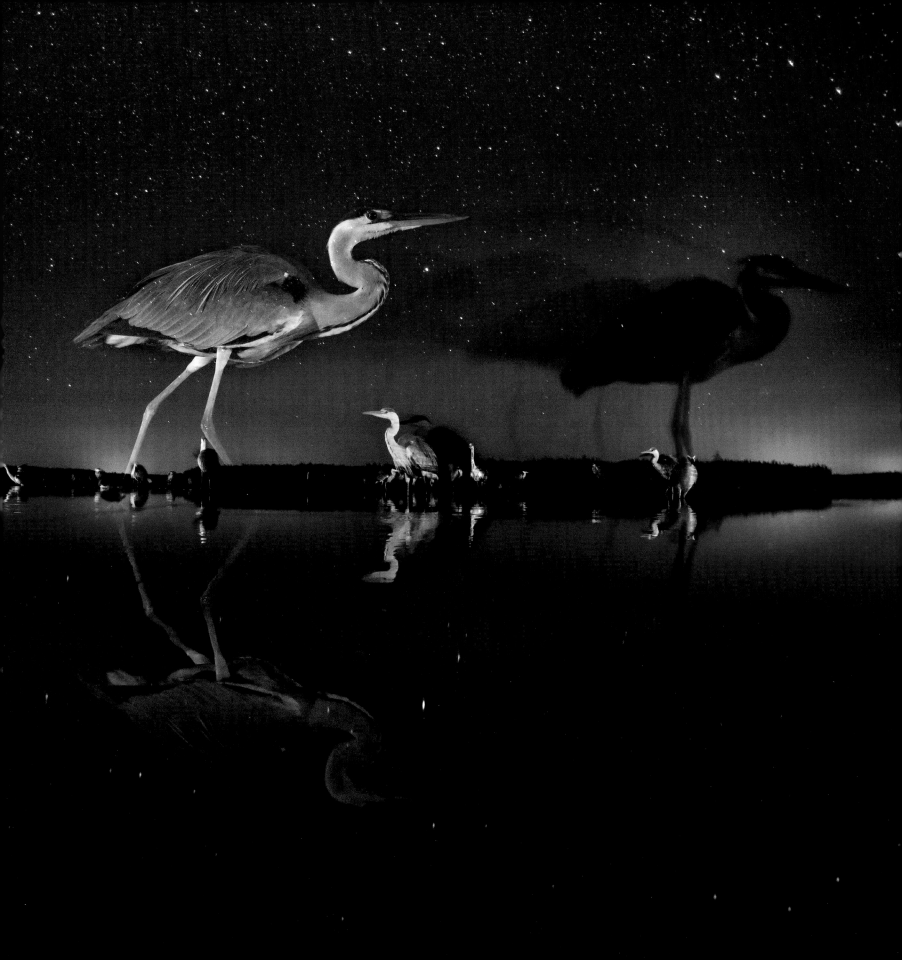

# Birds

## Herons in time and space
### Bence Máté

HUNGARY

The slightest sound would have scared the shy grey herons, and so Bence had to take great care while in his hide, overlooking Lake Csaj in Kiskunság National Park, Hungary. He had a specific image in mind, using both artificial and natural light. To solve the various technological challenges of such a night-time shot, he built two timing devices for the camera to execute the single exposure, one moving the focus and the other adjusting the aperture within a single frame, so both the herons and the stars were in focus. But it took 74 nights in the hide before the conditions were right and it all came together. The surface of the lake was still and reflected the stars, and the sky was clear and moonless. Just after midnight, as the seven stars of The Plough (part of the Ursa Major constellation) slid into the position he wanted over the glow of the distant town, Bence took the shot, with both the stars and the herons sharp enough and with the traces of the birds' movements leaving ghostly impressions against the sky. In a masterful blend of technology, ethology, astronomy, photography and personal passion, he had created a picture he had planned for several years – of herons imprinting their images in time and space.

**Nikon D800 + Sigma 15mm f2.8 lens; 32 sec (1 sec at f10, then 31 sec at f2.8)
+ two custom-made gadgets; ISO 2000; four flashes; tripod; hide.**

# Pauraque study

Jess Findlay

CANADA

One of Jess's hopes on his first trip to Estero Llano Grande State Park in southern Texas, USA, was to find a common pauraque. He had wanted to visit the region since he was a teenager, enticed by its reputation as a top birding destination, and he knew that the brushy woodland of the park was where this nightjar might be found roosting. Strictly nocturnal, it rests quietly by day among dense vegetation, blending perfectly with its surroundings, though at dusk and dawn, the whistling calls of males can help locate them. Having heard a male the evening before, Jess began exploring the woodland the next morning and was thrilled to find a common pauraque sleeping. Creeping to within a few metres, Jess set up his camera with a long lens and focused on the intricate markings of the bird's plumage. 'I liked the idea of making the viewer slowly discover the identity of the subject by looking first at the fine details,' he says – in this case, the beautiful patterns and tones of brown, black and gold that provide such perfect camouflage among the woodland leaf-litter.

**Canon EOS 5D Mark III + 400mm f5.6 lens + 12mm extension tube; 1/5 sec at f16; ISO 100; Gitzo tripod + Induro ballhead.**

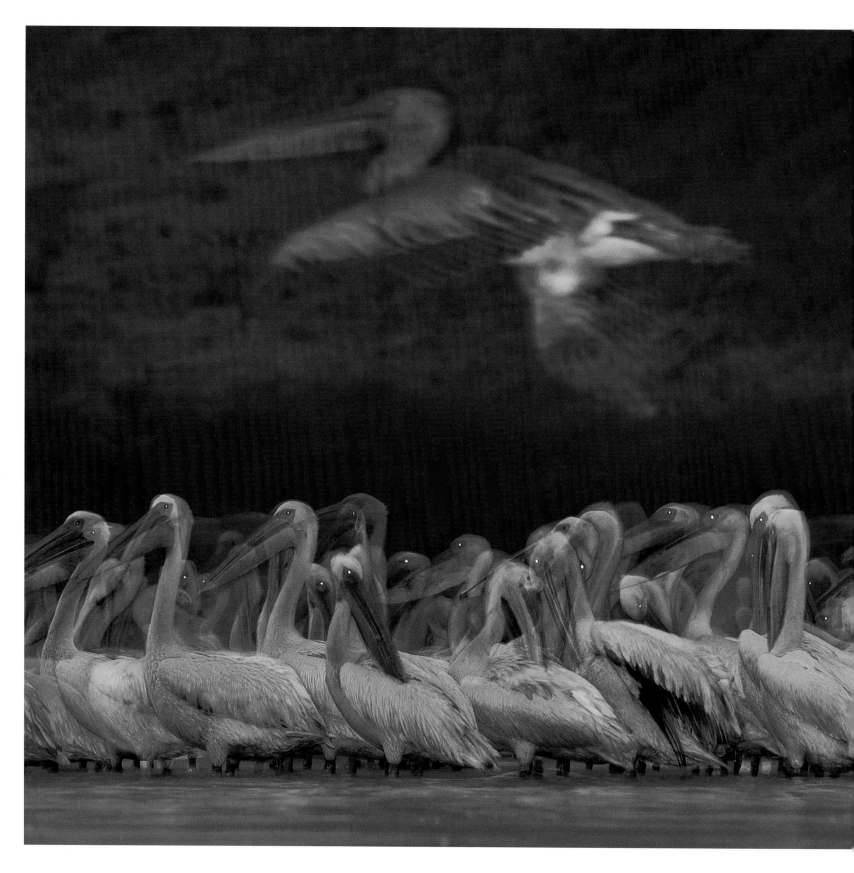

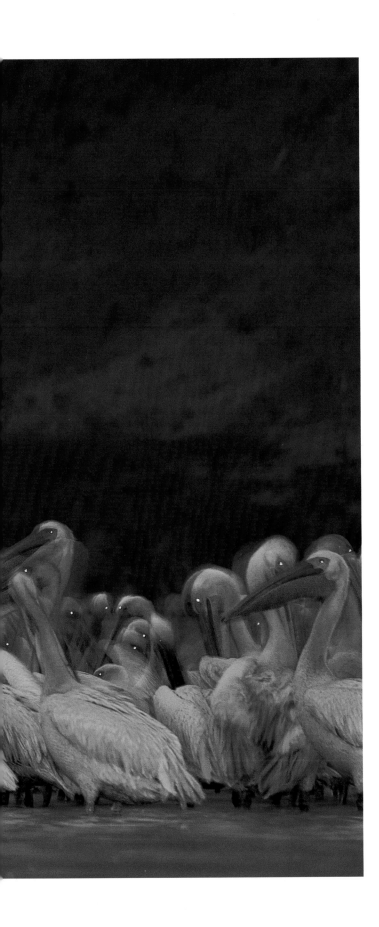

## Night of the pelicans
### Greg du Toit

SOUTH AFRICA

His car had broken down, he was alone in the bush, and it was getting dark. But the location was perfect. Stranded on the edge of Kenya's Lake Nakuru, Greg had a view of about 200 great white pelicans just settling down to roost. To get an eye-level view of the birds, he lay down at the lake's edge (alert for danger in the form of emerging hippos) and composed his shot. He decided on a long exposure to capture the atmosphere and timed it to include a pelican flying in. 'I would look down the valley to see if one was approaching. When I figured it was about three seconds away from being in the frame, I tripped the shutter.' A burst of flash was just powerful enough to create a ghostly impression of one of the stragglers, with the last of the ambient light reflected off the Rift Valley wall behind.

**Nikon D3s + 80–400mm f4.5–5.6 lens at 400mm; 3 sec at f16; ISO 200; Nikon SB-800 flash + remote cord; beanbag.**

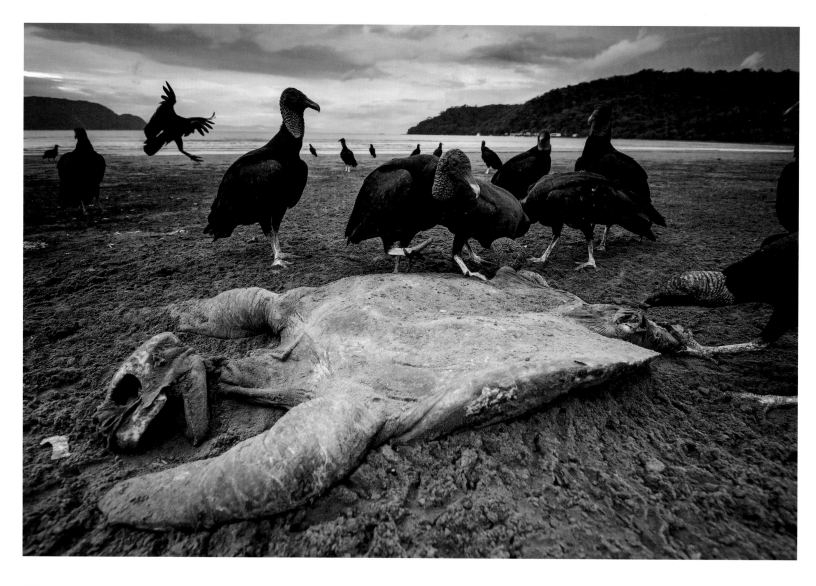

## Dinner party
### Nick Hawkins
CANADA

Walking along the shore on the Nicoya Peninsula, Costa Rica, Nick discovered the carcass of a Pacific green turtle. The endangered reptile was a likely bycatch victim – caught unintentionally, probably by a shrimp trawler, and then discarded. When Nick spotted American black vultures descending to feed, he seized the chance to highlight the issue. He set up his camera close to the carcass with a wide-angle lens and operated it remotely, so as not to disturb the vultures. In the low light, he had to balance the depth of field (amount in focus) and a shutter speed fast enough to freeze the movement of the birds and capture the story-telling image he wanted. The vultures continued to squabble over the meal for hours and had nearly devoured the entire carcass when the tide washed away the remains.

**Nikon D4 + 16–35mm f4 lens at 17mm; 1/640 sec at f6.3; ISO 3200; Nikon SB-700 flash; Gitzo tripod + Induro ballhead; remote shutter release.**

# Touché
## Jan van der Greef
THE NETHERLANDS

A focus of Jan's trip to Ecuador was the astonishing sword-billed hummingbird – the only bird with a bill longer than its body (excluding its tail). Its 11-centimetre (4.3-inch) bill is designed to reach nectar at the base of equally long tube-shaped flowers, but Jan discovered that it can have another use. One particular bird had a regular circuit through the forest, mapped out by its favourite red angel trumpet flowers and bird-feeders near Jan's lodge. To get to the bird-feeders, it had to cross the territory of a fiercely territorial collared inca. Rather than being scared off, once or twice a day 'it used its bill to make a statement'. To capture one of these stand-offs, Jan set up multiple flashes to freeze the hummingbirds' wing-beats – more than 60 a second – and finally captured the precise colourful moment.

Canon EOS-1D Mark IV + 300mm f2.8 lens; 1/250 sec at f16; ISO 400; Canon Speedlite 580EX flash + six Nikon Speedlight SB-26 flashes; Gitzo tripod + Wimberley head.

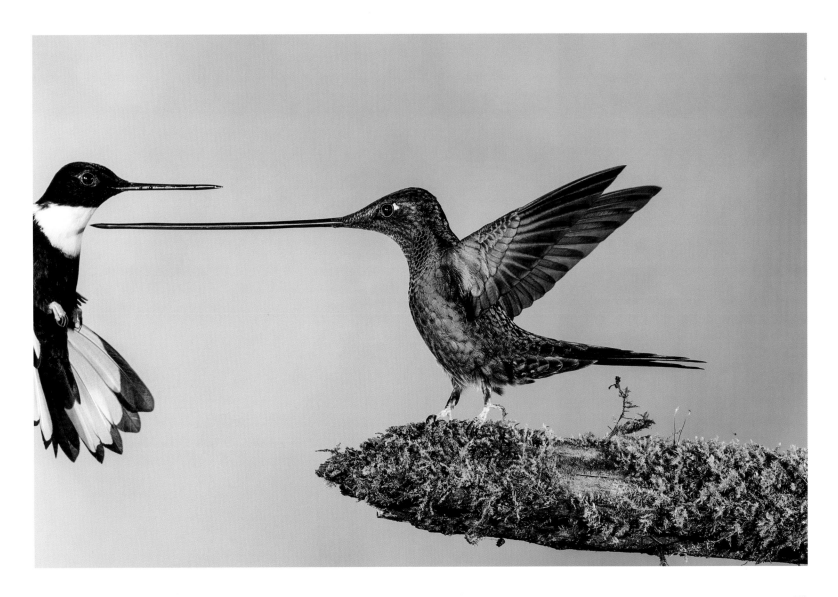

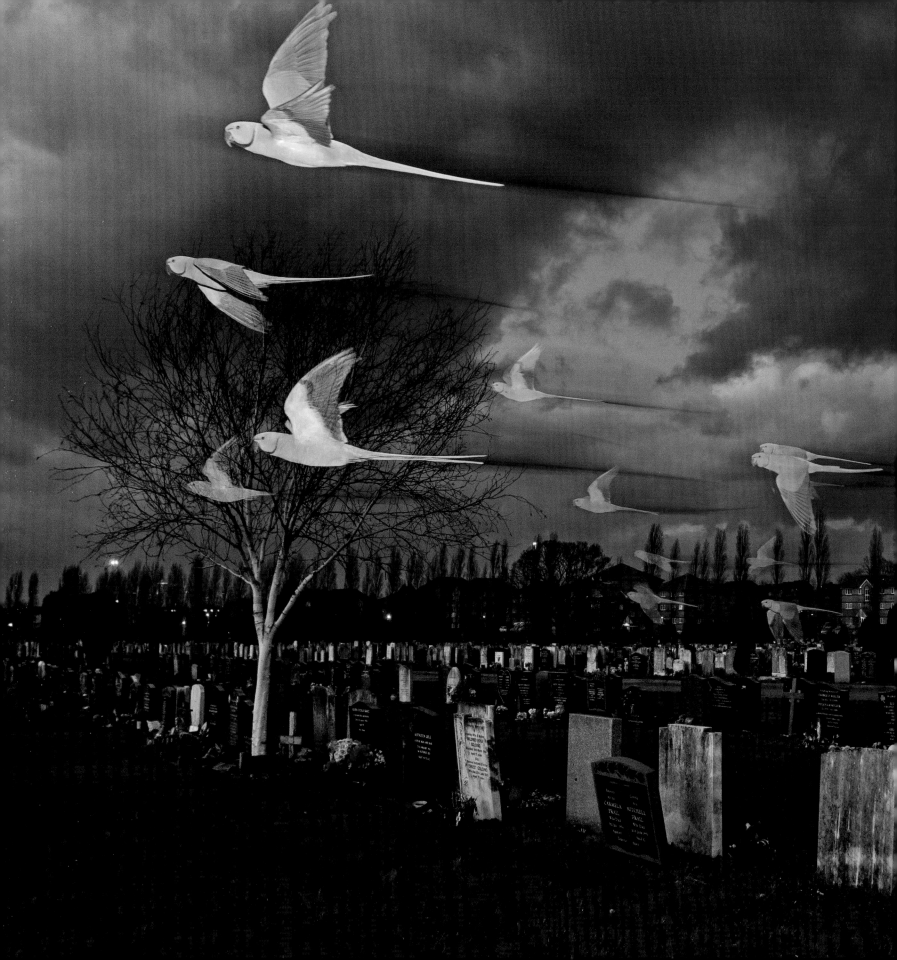

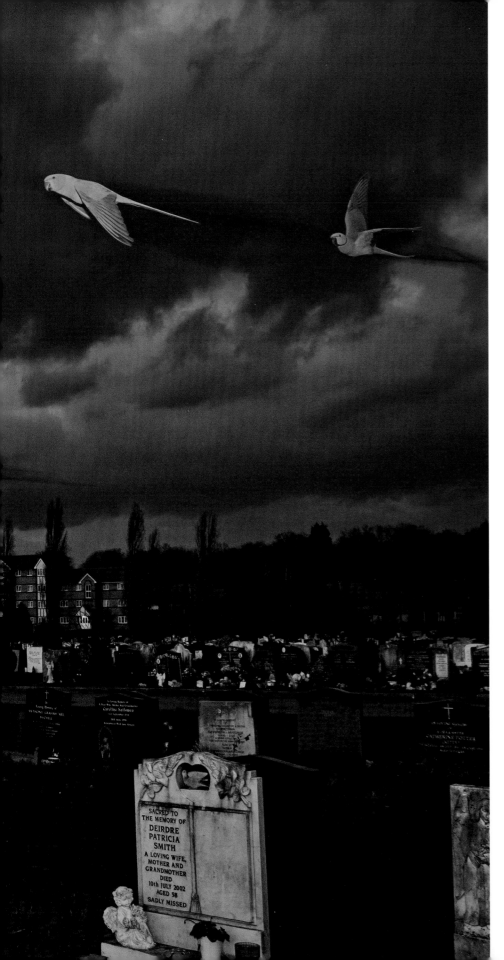

## Feral spirits
### Sam Hobson
UNITED KINGDOM

Just before dusk, the birds would suddenly start to appear. 'Swathes of them, coming in low across the cemetery – I'd keep having to duck – heading for their roost in the trees just behind me,' recalls Sam. Ring-necked parakeets, an Afro-Asian species, are now well established in the wild in Britain – a result of escapes and deliberate releases of captive birds – and they are thriving in London. Their winter roosts can be huge; Sam had checked out several before opting for this one in a London cemetery, where 'there were probably 5,000 birds – the noise was amazing.' With a constant stream of arrivals in groups of 20–30, squawking their way past, Sam worked out the parakeets' typical flight paths, set up his kit, experimented with various techniques and realized they were coming close enough for him to use a wide-angle lens. With a burst of flash at the end of a long exposure to create their ghostly trails, Sam conveyed the essence of these cemetery dwellers – eye-catching aliens in the English urban landscape. By the time it was dark, an hour and a half after the first arrival, the fly-past of thousands was complete.

**Nikon D7000 + 17–35mm f2.8 lens at 17mm; 1/30 sec at f6.3; ISO 800; Nikon Speedlight SB-800 flash + PocketWizard Plus III remote release; Manfrotto tripod.**

# Earth's
# Environments

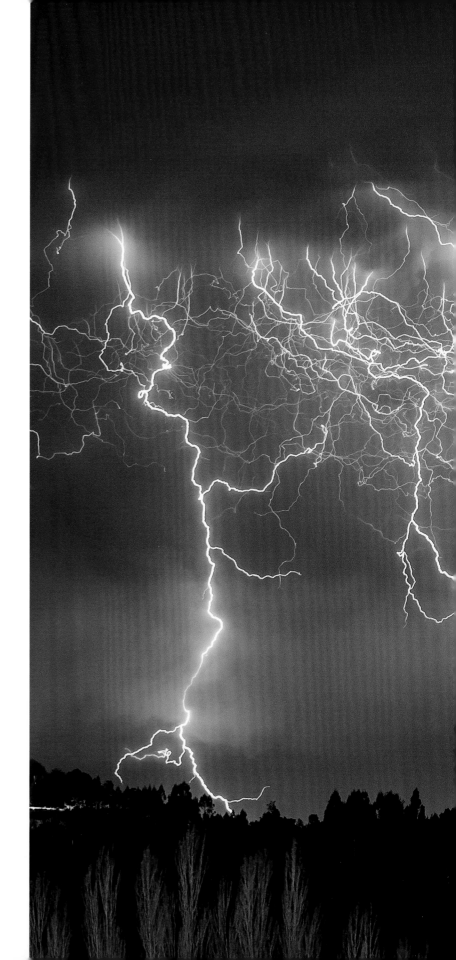

## Apocalypse
### Francisco Negroni

CHILE

Straight after the Puyehue-Cordón Caulle volcanic complex began erupting, Francisco travelled to Puyehue National Park in southern Chile, anticipating a spectacular light show. But what he witnessed was more like an apocalypse. From his viewpoint – a hill quite a distance to the west of the volcano – he watched, awestruck, as flashes of lightning lacerated the sky and the glow from the molten lava lit up the smoke billowing upwards and illuminated the landscape. 'It was the most incredible thing I have seen in my life.' Volcanic lightning (also known as a 'dirty thunderstorm') is a rare, short-lived phenomenon probably caused by the static electrical charges resulting from the crashing together of fragments of red-hot rock, ash and vapour high in the volcanic plume. The Cordón Caulle eruption spewed 100 million tonnes of ash high into the atmosphere, causing widespread disruption to air travel in the southern hemisphere. Volcanic activity continued at a lesser level for a year, spreading a layer of ash over the region.

**Nikon D300 + Sigma 70–200mm f2.8 lens; 1/541 sec at f2.8; ISO 200; tripod; remote control.**

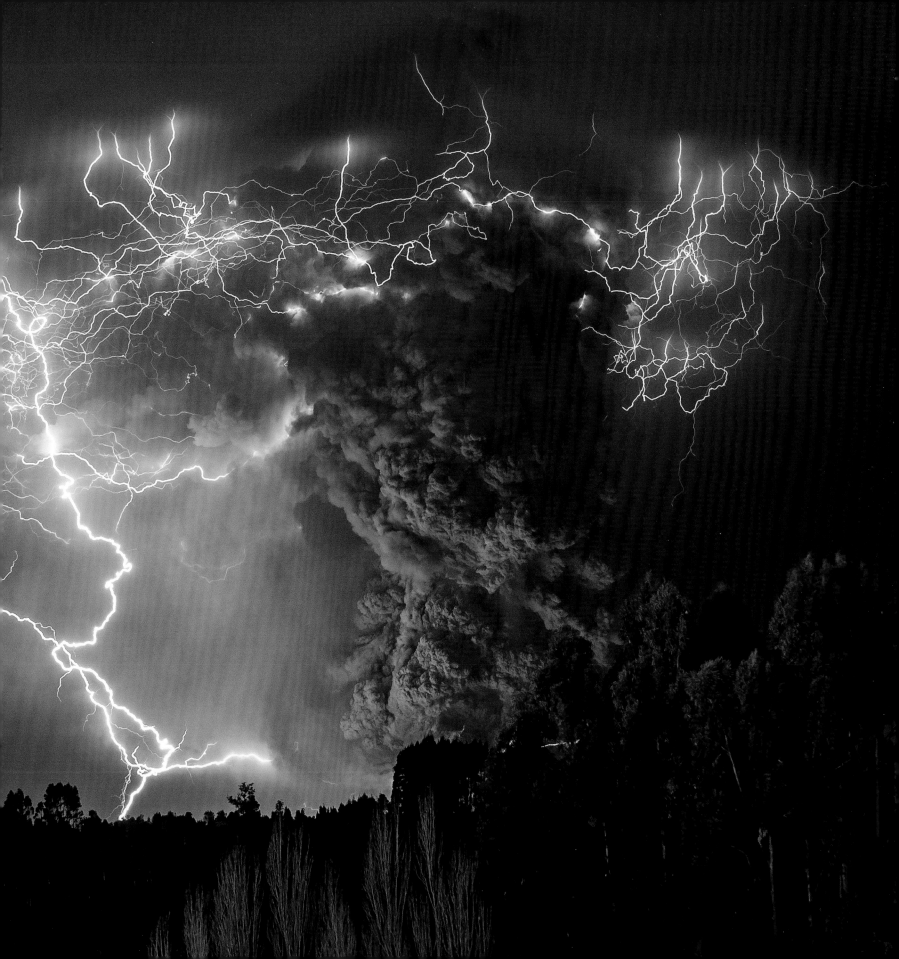

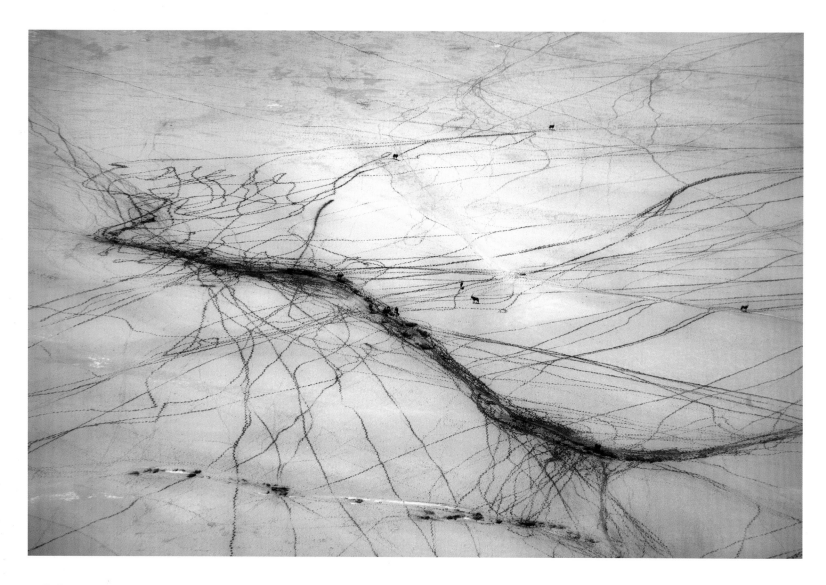

## Lifelines
### Paul van Schalkwyk
NAMIBIA

As a photographer with an eye for graphic compositions and a passion for wild places, Paul was drawn to arid landscapes. He often flew over Etosha Pan, Namibia, shooting through the open door of his small plane. Wildlife is rarely seen on this huge salt pan – once a lake bed – but these gemsbok are adapted to arid conditions, active only in the cooler parts of the day and night, and can go without drinking for long periods. Despite the glare from the baked clay, sand and salts, Paul managed to create a pattern from the tangle of their tracks – some leading nowhere, perhaps made by animals seeking relief from the heat only to find themselves fooled by a mirage, or looking for water that has long vanished under the sand.

**Nikon D700 + 35–120mm lens; ISO 200.**

*Photographer and film-maker Paul van Schalkwyk was killed in March 2014, flying solo, when his plane crashed over the Etosha Pan, Namibia.*

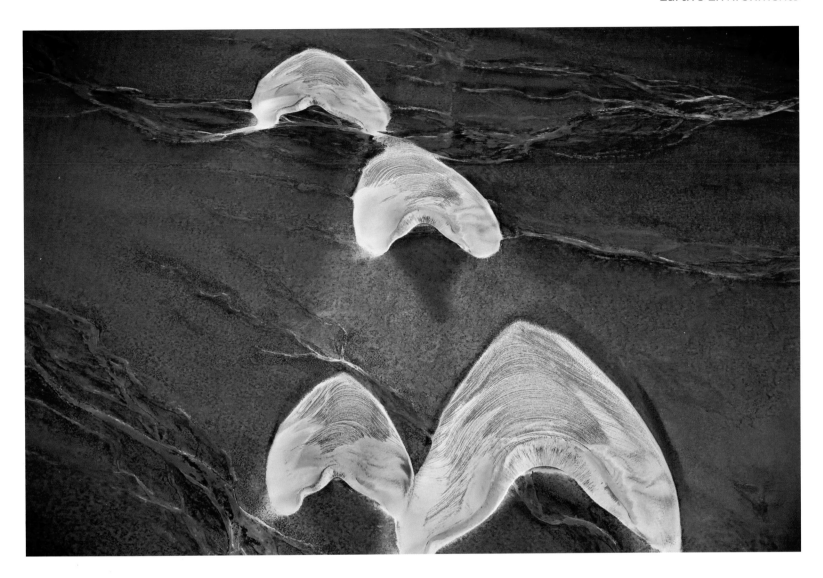

## Shifting sands
Paul van Schalkwyk

NAMIBIA

Paul photographed these mysterious migrating dunes in the low afternoon sun, while flying over one of his favourite places – Namibia's Skeleton Coast. His aim was always to create intriguing abstracts through which he could share his joy of wilderness and inspire others to value such wild places. The wandering dunes have been created by southwesterly winds carrying sand inland from the coast to the gravel plains. Moulded into alien shapes, they are on a slow march – just a few centimetres a year – to a dune belt farther north. When photographing aerials from a fast-moving, small aircraft, timing is key. But it was not Paul's only challenge. He used a heavy, medium-format camera – the best for landscape – and would shoot through the open door while at the same time flying his plane. Indeed, he listed planes among his photographic equipment for taking photographs of the ever-changing beauty of his beloved desert.

**Phase One P65+ & 150mm lens; ISO 200.**

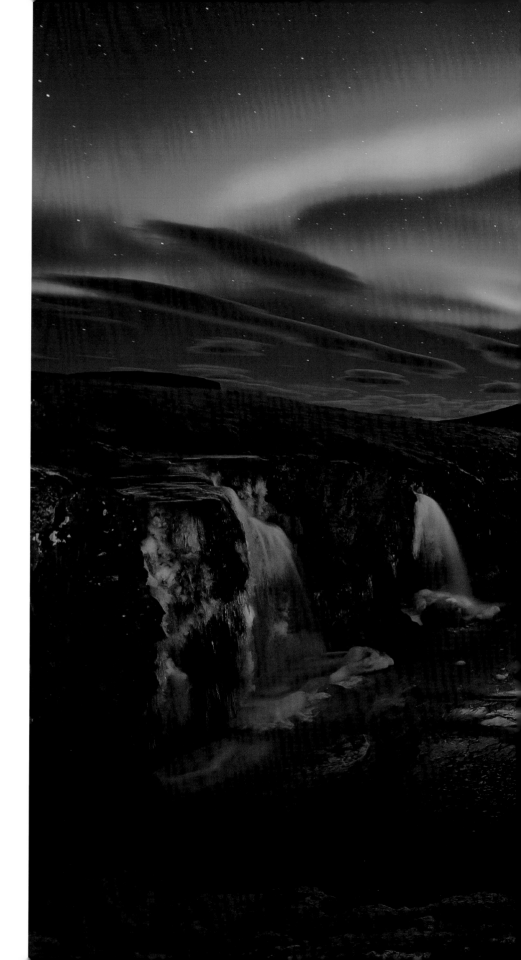

## Magic mountain
### David Clapp
UNITED KINGDOM

At 2am, the intensity of the aurora light suddenly changed and a great burst pulsed across the sky in a totally unexpected formation. David had travelled to Iceland partly to photograph the auroras, choosing the Snaefellsnes Peninsula as the location because of its spectacular scenery. He had first set up by the frozen river below Mount Kirkjufell, but when the show intensified, he scrambled up the bank to a preplanned viewpoint with the mountain as the focus. The colour of an aurora – the result of collisions between electrically charged particles from space and oxygen and nitrogen atoms high up in the Earth's atmosphere – depends on the type of gas, in this case, yellowish-green, resulting from collisions with oxygen. David concentrated on the light behind the mountain, carefully composing the shot to create the illusion that the curtains of light encircled the peak. As the light intensified, so did the contrast. 'I slightly underexposed the image to avoid burning out the highlights and painted light on the foreground with my head torch,' says David. What provided the extra magic were the otherworldly lenticular clouds hovering over the waterfall, echoed in the patterns of ice, and the green light reflecting off the frozen river.

Canon EOS-1D X; 24mm f1.4 lens; 30 sec at f2.8; ISO 1600; Gitzo tripod 5540 + Kirk ballhead; head torch.

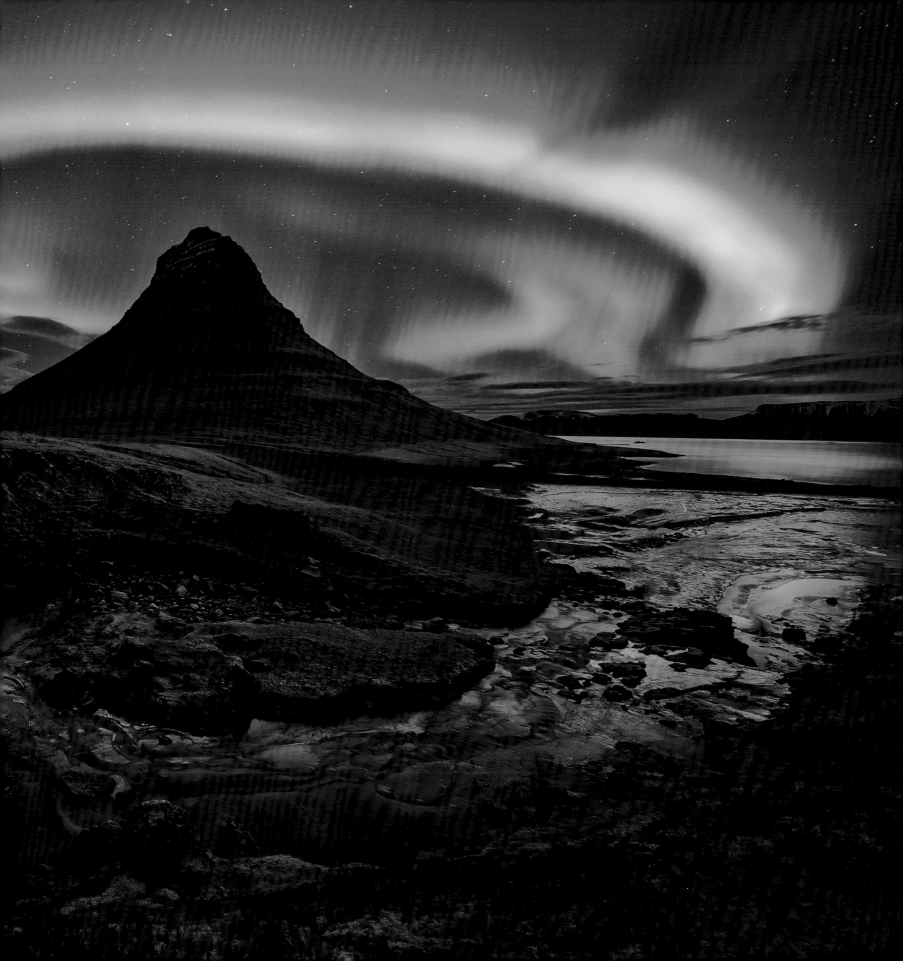

# Delta design
## Hans Strand
SWEDEN

Wild landscapes are what Hans is drawn to, and Iceland seen from the air
has provided him with an endless variety of colour and form. 'The rivers and
deltas change from day to day – so you never know what you will accomplish.'
Circling the delta of the Fúlakvisl, battling against motion sickness in strong
winds, he shot almost continuously. The river, murky with silt from the
Langjökull Glacier, appeared as tangled, silvery threads, criss-crossing over the
black volcanic soil, with pools of gold – iron oxide sediment – on the banks.
This picture, taken from the open window of the aircraft, was cropped to a
vertical format to enhance the pattern of the river branches. It was one of
the last he shot before the winds finally forced the flight to be aborted.

**Hasselblad H3DII-50 + 80mm lens; 1/800 sec at f4.8; ISO 200.**

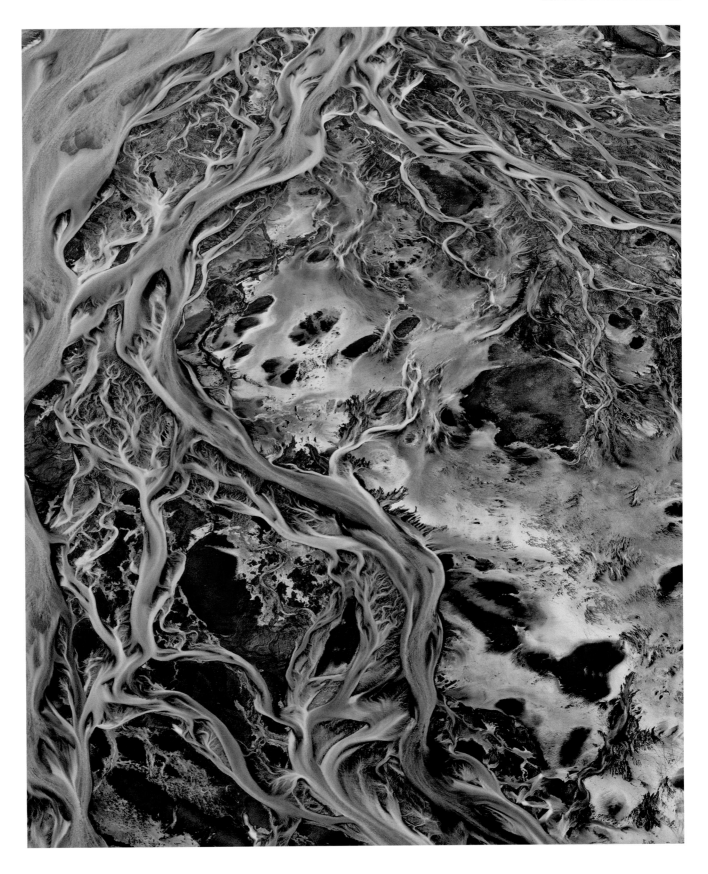

# Blown away

## Dana Allen

USA

Dana was intent on showing his clients the magnificent dunes of Namib-Naukluft National Park, Namibia – among the highest in the world. But on this day, it was so windy and the air in the dry riverbed so full of powdery sand that he nearly gave up. In this spot, though, there was relative calm, and the skeleton acacia tree, dwarfed by the massive dune, gave a sense of scale. What fascinated him most were the moving patterns of sand. 'The shifting winds made the sand dance across the shaded side of the dune like the flames of a fire,' he recalls.

**Nikon D4 + 80–400mm f4.5–5.6 lens at 400mm; 1/500 sec at f9.5; ISO 200; Gitzo tripod + Really Right Stuff ballhead.**

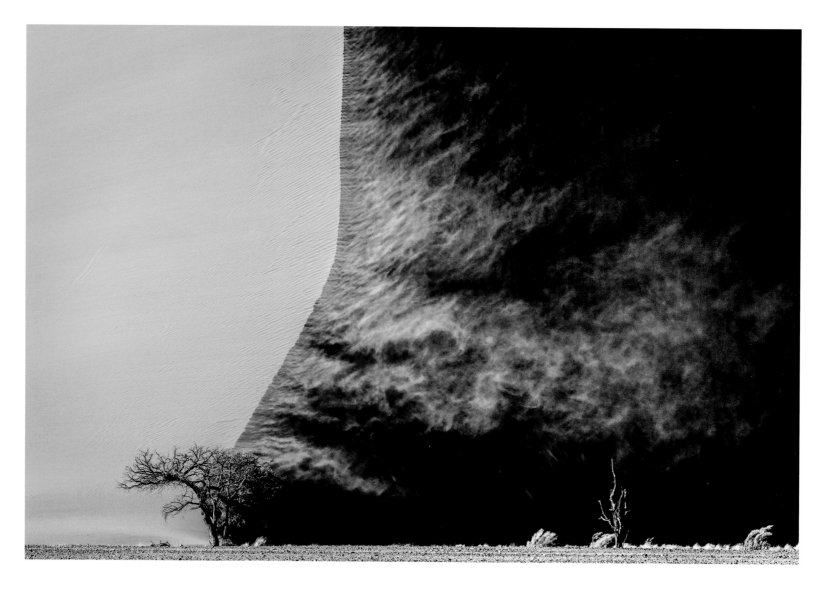

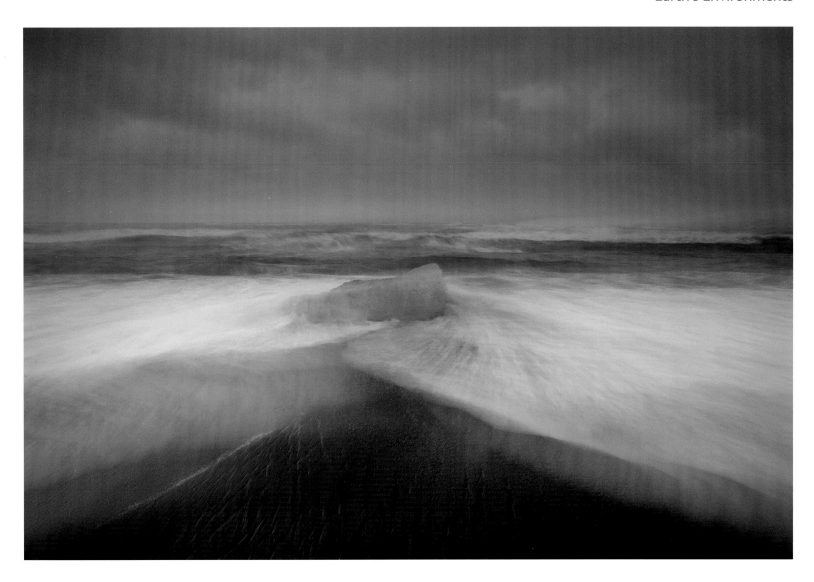

# Ice land
## Alessandro Carboni
ITALY

Passionate about the landscape of his Mediterranean home, the island of Sardinia, Alessandro chose to visit an island that couldn't be more different – Iceland – 'place of fire, ice and stormy seas'. His location was Jökulsárlón, a glacial lagoon, famous for its blue ice. He wanted to convey a feeling of its remoteness, the power of the elements and the beauty of the colours. Focusing on a single block of ice stranded on the volcanic beach, he set it centre-frame and, using a long exposure and low-level view, concentrated on the pattern of black sand left by the withdrawing surf. High winds and spray meant that it took many attempts to capture both the pull of the ocean and the subtle colour contrasts of sky, sea and ice.

**Nikon D700 + Zeiss Distagon 21mm f2.8 lens + Lee 0.75 ND graduated filter; 1.3 sec at f16; ISO 200; Gitzo tripod.**

# Underwater Species

## Passing giants
### Indra Swari Wonowidjojo
INDONESIA

During the new moon, the lights from the bagans (semi-mobile fishing platforms) in Cenderawasih Bay in Irian Jaya, Indonesia, attract shoals of fish into the nets of local fishermen. The lights act as a signal to filter-feeding whale sharks, which have learned to suck on the nets and extract the fish mush. It's an easy meal, so easy that the whale sharks sometimes need to be shooed away from the nets, though some fishermen also feed them. Up to 10 whale sharks can cruise around a bagan at any one time, and now the location is becoming a dive hotspot. Attracted by the spectacle, Indra spent a few days diving there. As a huge whale shark – at least 9 metres (30 feet) long – passed near to her on one dive, she noticed another swimming a little deeper, in a different direction. She swam quickly to position herself so that she could be above both of them when their paths crossed, adjusting her strobe output and ISO so the great fish would both be illuminated to the right extent. The sharks showed few signs of being bothered by her presence. 'They will happily swim straight into you, gently nudging you out of their way,' she says. 'The fishermen see them as good omens and often jump in and swim with them.' Elsewhere in Asia, these massive animals – the world's largest fish – continue to be hunted.

Canon EOS 5D Mark II + 17–40mm lens; 1/100 sec at f11; ISO 640; Nexus housing + Inon z240 strobes.

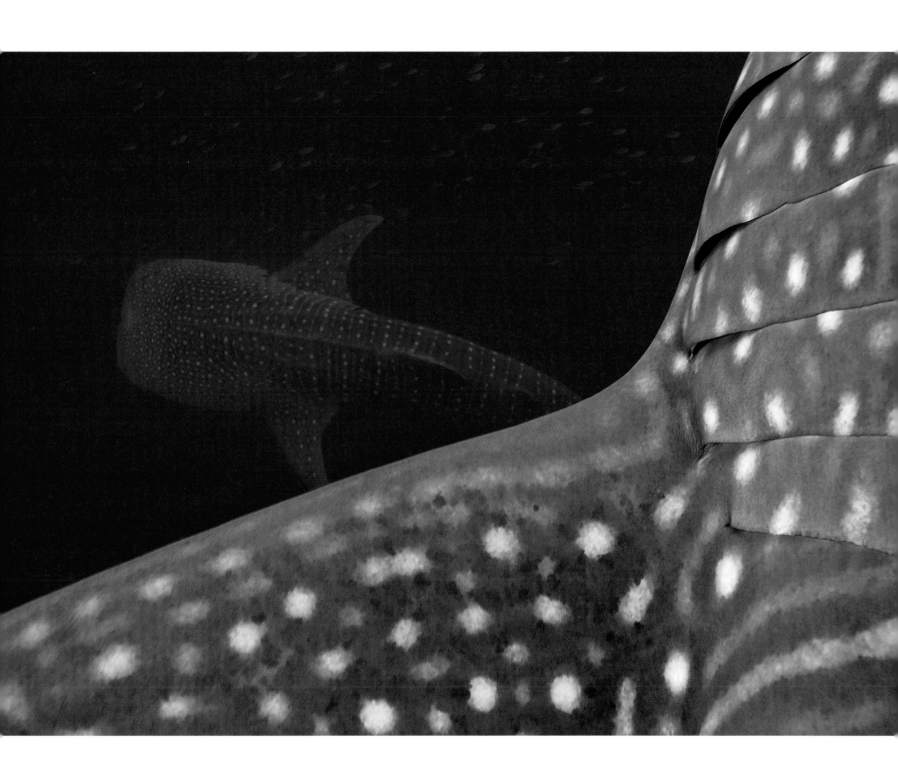

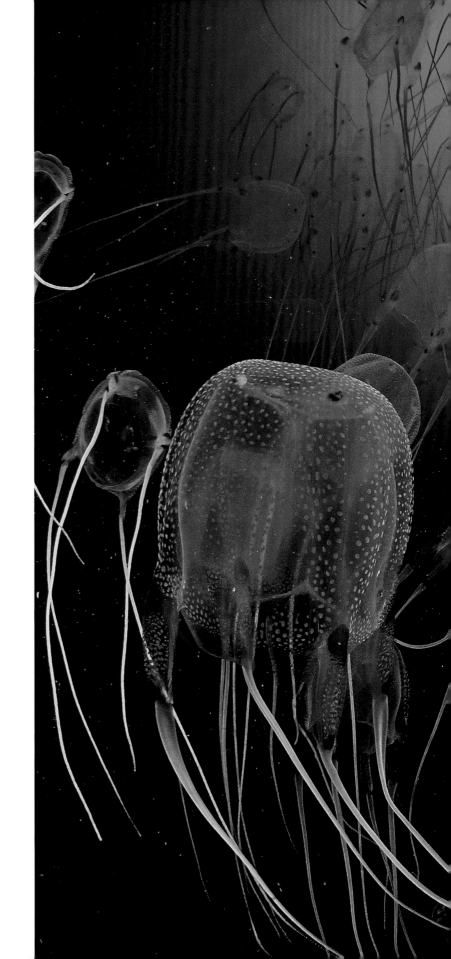

# Jelly fireworks
## Geo Cloete
SOUTH AFRICA

Geo never forgot the vast swarm of box jellyfish he encountered when diving in Hout Bay off Cape Town. He had no camera then, but the experience sparked a passion for jellyfish, and he fantasized about creating a picture of a huge mass of them, moving 'like a firework display in slow motion', their tentacles like star trails. Though Geo occasionally found small groups of box jellyfish around South Africa's Cape Peninsula, it was seven years before he came across another mass gathering. It was in exactly the same location, in plankton-cloudy water. The 500 or so tightly packed cube-shaped bells would shoot forward when they saw him. (Though these small jellyfish have no central nervous system, they have clusters of eyes on the four sides of their bells and, unlike most other jellyfish, they can jet away.) 'Visibility was bad, and so I needed to manoeuvre them so that they were nearer the surface and I could look up at them and outline them against the sunlight.' Swimming into the mass, braving the stings from their tentacles, and with skilful positioning of his strobes to light rather than bleach those in the foreground, he managed to capture the otherworldly image he had in mind.

Nikon D300 + Tokina 10–17mm f3.5–4.5 lens at 10mm; 1/320 sec at f16; ISO 160; Seatool housing; two Inon Z-240 strobes.

# Dolphin downtime

Brian Skerry

USA

Brian travelled to the waters off northwest Oahu, Hawaii, to photograph spinner dolphins as part of a scientific project examining dolphin intelligence. The researchers were looking in particular at social alliances and feeding strategies. Spinners are well known for their acrobatics, leaping up to 3 metres (10 feet) out of the water and completing as many as seven revolutions in the air before plunging in again. It is not certain why they do this, though it may be to dislodge remoras (suckerfish) and for communication. Their spinning once caused them to be targeted for aquariums, but they are hugely social – living in large pods of up to 200 individuals – and so have never survived well in captivity. The dolphins Brian was working with foraged at night on fish, squid and shrimps in deep water offshore, then came into shallow bays in the early morning to socialize and rest. Harassment from dolphin-watching boats is a problem, and so Brian was careful to position himself off to the side so as not to disturb the pod. Free-diving to a depth of nearly 18 metres (nearly 60 feet), he took advantage of the white sand backdrop to create his picture – a moment of dolphin downtime, his subjects relaxed in their world.

**Nikon D4 + 17–35mm lens at 24mm; 1/500 sec at f11; ISO 1000; Subal housing.**

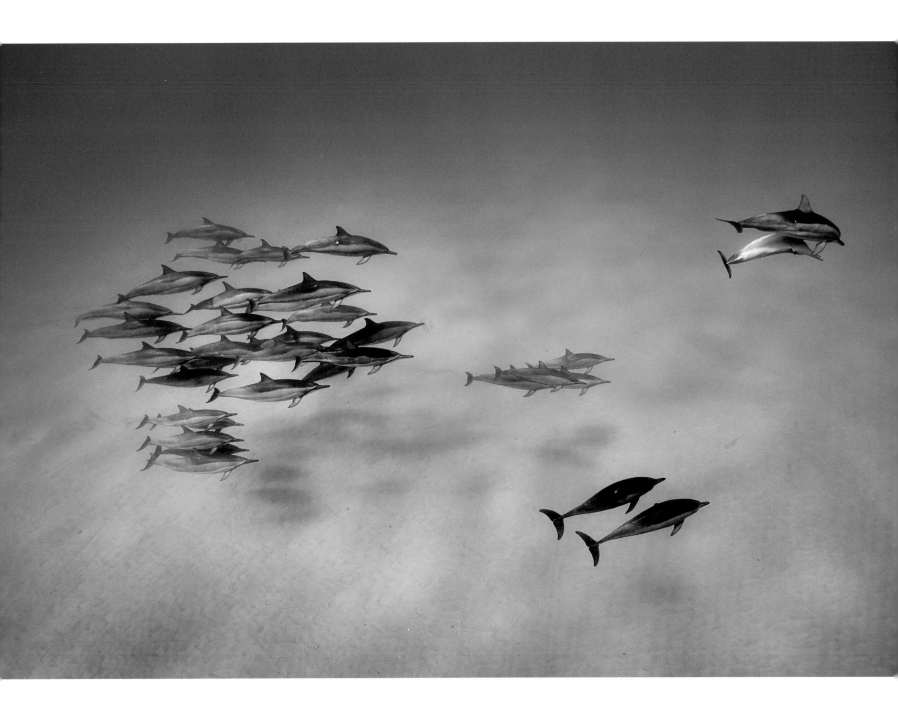

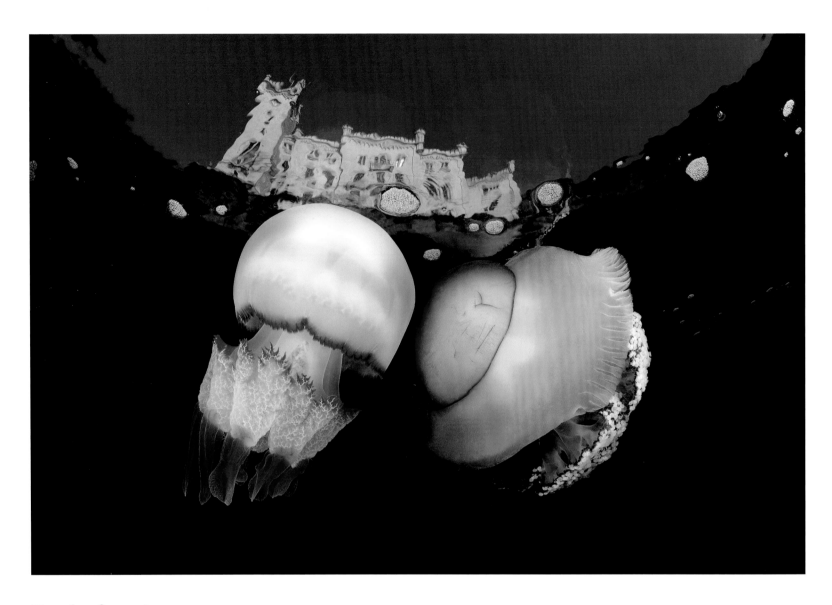

## Touch of magic

Adriano Morettin

ITALY

Adriano had this picture in mind for 15 years before he had a chance to capture it. The nineteenth-century Miramare Castle, near his home in Trieste, stands on a cliff overlooking the Adriatic Sea. Last summer, a significant jellyfish swarm gathered beneath the cliffs – hundreds of barrel jellyfish and tens of fried-egg jellyfish in unusually clear water. Adriano needed to get close with his wide-angle lens, receiving many minor stings to his face in the process. But his real challenge was to follow the jellyfish as they moved – 'using their domes like engines' – waiting for two to touch near the surface and getting just the right angle to photograph them with the castle behind. Most difficult of all was balancing the exposure of the jellyfish with that of the sunlit castle above to reveal the beauty of both.

Nikon D800E + Sigma 15mm f2.8 lens; 1/160 sec at f18; ISO 100; Seacam housing + Superdome; two Seaflash 150 strobes.

# Silver streak
## Chris Gug
USA

Shooting specifically to create fine-art prints, Chris was drawn to this massive gorgonian coral by the combination of strong colours and the 3-D feel created by his ultra-wide-angle lens. At more than 4 metres (13 feet) across, it was the largest gorgonian he had ever seen, and by day it sheltered a shoal of tiny cardinalfish, hiding them from the circling mackerel, jacks and other predators. Chris dived in this location every week for much of his two-year expedition to Papua New Guinea. 'I was very familiar with this coral', he says, 'and had pre-visualized many compositions, but on this occasion, the cardinalfish were resting in a tighter vertical shoal than I could have hoped for.' The greatest challenge was getting close to the coral without touching and therefore harming it and positioning his strobes (above and below) without spooking the fish. He achieved the composition he was after and even managed to reveal that some of the cardinalfish had extended throat pouches, indicating that they were males incubating clutches of eggs in their mouths.

**Nikon D90 + 10–17mm f3.5–4.5 lens at 17mm; 1/50 sec at f14; ISO 100; Aquatica housing; two Ikelite DS-161 strobes.**

# Ocean blues
## Jordi Chias Pujol
SPAIN

Diving off Santa Maria Island in the Azores, Jordi relished his close encounters with the blue sharks. 'Sometimes they came within centimetres,' he says. 'They're such beautiful animals, such elegant swimmers – it was a great spectacle.' Blue sharks are widespread and presumed abundant (there are no population estimates), migrating vast distances across the Atlantic, feeding mainly on bony fish and squid. But there is concern for their future. They are the most heavily fished shark species, with an unsustainable annual catch estimated at 20 million, mostly as longline and driftnet fishery bycatch. Many are landed in European waters, their fins sold for the Asian market. There is now a campaign to create a shark sanctuary around the Azores, given that shark-diving in the area is a more lucrative industry than fishing. Jordi was specifically after blue shark pictures and spent a while shooting wide-angle images before turning his attention to the detail of their slender bodies. He had in mind a picture of two blues – one in close-up, one further away in profile – but with the sharks constantly cruising, framing the right moment was a challenge. When they fleetingly aligned, he was ready, capturing the perfect blue shark portrait.

**Canon EOS 5D + 17–40mm f4 lens; 1/80 sec at f13; ISO 200; custom-built housing; two Inon Z-220 strobes.**

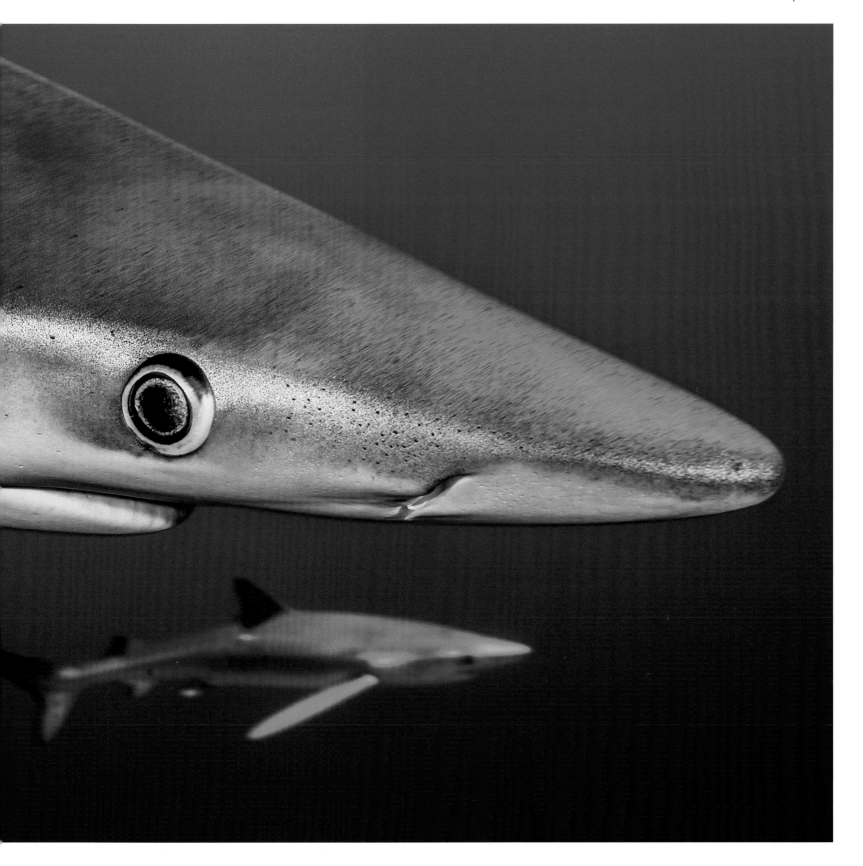

# Little squid

Fabien Michenet

FRANCE

Planktonic animals are usually photographed under controlled situations, after they've been caught, but Fabien is fascinated by the beauty of their living forms and aims to photograph their natural behaviour in the wild. Night-diving in deep water off the coast of Tahiti, in complete silence apart from the occasional sound of dolphins, and surrounded by a mass of tiny planktonic animals, he became fascinated by this juvenile sharpear enope squid.

Just 3 centimetres (an inch) long, it was floating motionless about 20 metres (66 feet) below the surface, probably hunting even smaller creatures that had migrated up to feed under cover of darkness. Its transparent body was covered with polka dots of pigment-filled cells, and below its eyes were bioluminescent organs. Knowing it would be sensitive to light and movement, Fabien gradually manoeuvred in front of it, trying to hang as motionless as his subject. Using as little light as possible to get the autofocus working, he finally triggered the strobes and took the squid's portrait before it disappeared into the deep.

**Nikon D800 + 105mm f2.8 lens; 1/320 sec at f16; ISO 200; Nauticam housing; two Inon Z-240 strobes.**

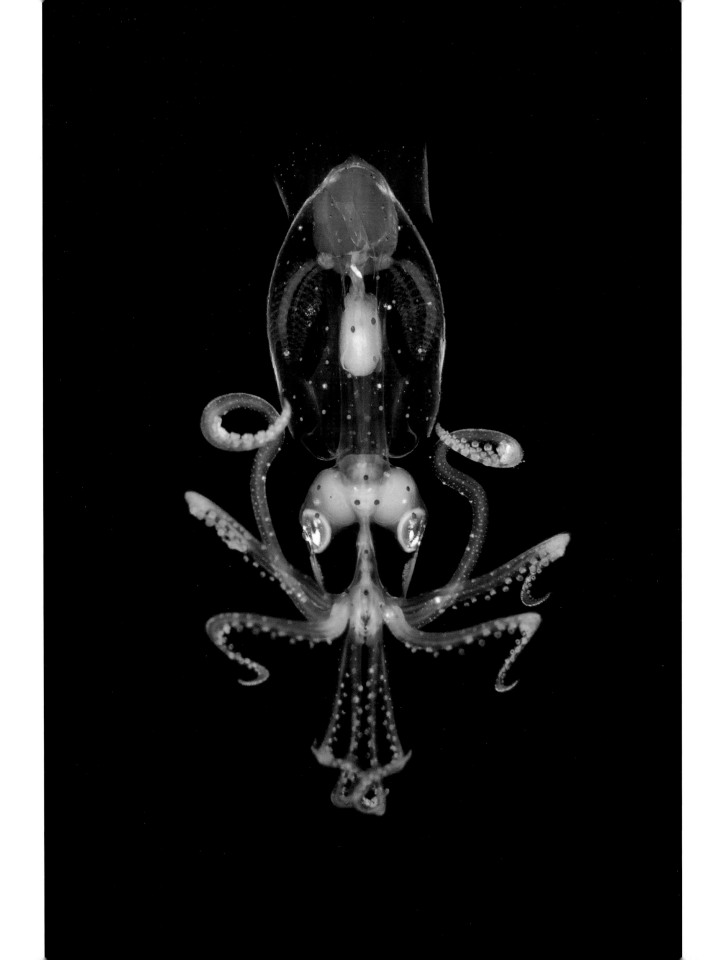

# Natural Design

## Cardinal sparks
### Patrik Bartuska
CZECH REPUBLIC

It was the contrasts in movement and texture that entranced Patrik – the soft tentacles swaying in the current and the flicks of the angular, patterned fish sheltering within the anemone. He had encountered the show while diving in the Lembeh Strait in northern Sulawesi, Indonesia. It had been his goal to photograph a group of the beautiful Banggai cardinalfish – found only in the waters off Sulawesi and endangered because of overfishing for the aquarium trade. Mostly he encountered small groups of adults around the coral. But what he was after was a group associating with an anemone – juveniles, which in the day make use of the protection of the tentacles, either avoiding their stings or in some way unaffected by them. It took many dives before he found this large grouping. Together, they appeared to Patrik like an underwater fire display, the tentacles like licking flames and the fish like erratic sparks. To capture the moving pattern he chose to shoot from above, holding his position in the current and waiting for the moment when the fish sparks flew and he could frame the composition.

**Canon EOS 5D Mark II + 16–35mm f2.8 lens; 1/8 sec at f9; ISO 320; Seacam housing; Seaflash strobes.**

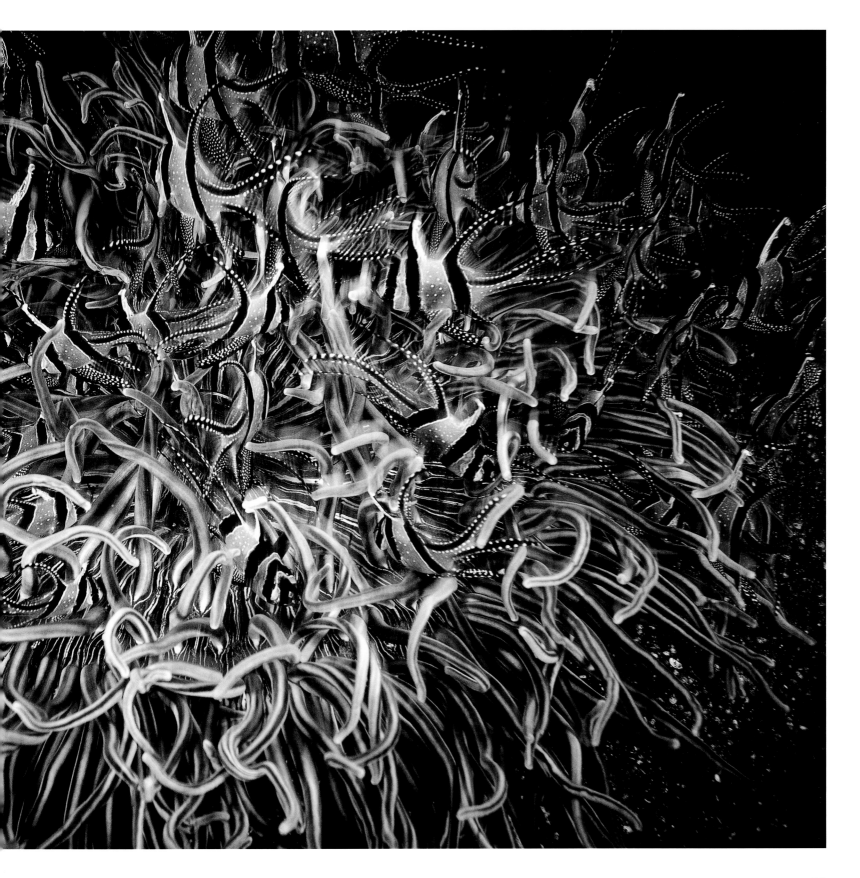

# Kaleidoscope
## Bernardo Cesare

ITALY

A geological event half a billion years ago, at extreme heat deep within the continental crust, gave rise to this crystal formation. The black mineral, appearing like lead frames in a stained-glass window, is graphite, traversing the colourful panels of quartz and feldspar. Bernardo uses photomicrographs (images taken through optical microscopes) to study rocks and minerals, as well as taking pictures with artistic intent. Examining this granulite rock from a working quarry in Kerala, India, he realized its aesthetic potential. 'I needed a carefully polished section, so thin that it was transparent,' explains Bernardo. When he transmitted polarized light through the ultra-thin slice, the interaction of the rays caused the minerals to display their natural interference colours. He inserted a colourless piece of quartz (a red-tint plate) into the optical path, which shifted the waves to transform shades of grey into blues and purples. His main challenge was the grain size of the rock – 'almost too coarse for my equipment' – necessitating a lower-magnification lens of 2.5x. 'My aim is to reveal the beauty of a small world that is normally accessible only to geologists', he explains, 'and through images such as this to tell the fascinating story of our planet.'

**Canon EOS 550D + Zeiss Axioskop 40 Pol microscope + crossed polarizers + red-tint plate; 1/15 sec; ISO 100.**

# The tracheal tree
## David Maitland

UNITED KINGDOM

'Like a Medusa from another world, this dissected tracheal tree from a wild silkmoth caterpillar seems to loom out from the depths,' says David. Trachea are the 'lungs' of an insect – branched networks of tubes that deliver oxygen directly to every part of the body. The tiny passageways are prevented from collapsing by hoops of chitin, giving them a ridged appearance (an insect's exoskeleton is also made up of chitin). 'I find the fine structure of nature fascinating,' says David, who captured this image from an old Edwardian microscope slide, using the very high magnification of a light microscope. 'Once I had selected the frame of view, the main challenge was to adjust the lighting to create the atmosphere that I wanted.' Working with a very shallow depth of field (amount in focus) and little light, he revealed the exquisite detail of a caterpillar's life-support system that would normally remain invisible to our eyes.

**Canon EOS 5D Mark II + Olympus BX51 microscope at x40; 0.8 sec; ISO 50; differential interference contrast lighting.**

# Murmuration in the storm

## Andrew Forsyth

UNITED KINGDOM

Andrew started following the starling murmurations in November 2013 at their roosts in Brighton, on Britain's south coast, learning their complex patterns and timings. 'Many photographers have explored this subject, and so I challenged myself to find a new way to capture the spectacle.' At the end of the day, on returning from foraging, the starlings gather in large groups – their winter numbers boosted by thousands of migrants from Europe – to perform spellbinding aerial shows before heading to communal roosts for the night. 'I started simply documenting the murmurations,' explains Andrew, 'moving on to setting them against cityscapes. And by February I was creating more expressive shots using hand-held, longer exposures.' Towards the end of a large murmuration, the Brighton birds would split into small groups, displaying ever closer to the water until they were only just clearing the surface. Despite the severe storms that hit the coast that winter, they continued to perform this routine every night, risking being overwhelmed by the high winds and breaking waves. Shooting directly into the lashing rain – 'I was constantly cleaning my lens' – Andrew balanced the motion blur he wanted against elements of clarity in the frame. With the stormy sea a dramatic backdrop, he captured the traces of murmuring starlings, as if disappearing into the wind and waves.

**Canon EOS 5D Mark III + 100–400mm f4.5–5.6 lens; 1/6 sec at f22 (+1 e/v); ISO 200.**

# Edge of creation

Andrew Lee

USA

In December 2012, for the first time in several years, the lava flow from Kīlauea volcano, on Hawaii's Big Island, entered the ocean. As soon as he heard the news, Andrew flew to Hawaii to witness 'the chaotic process of creation' for himself. On a very dark, cold night, in rain and high winds, he made the three-hour hike from Hilo. 'The black lava rocks were slippery, sharp and very hot – every step had to be carefully placed,' he recalls. 'The lava channels glowed in the dark, like an army of red serpents marching to the sea, but nothing prepared me for the extraordinary scene.' The wind had whipped up huge waves that were crashing into the jagged cliffs, creating an immense salty spray. The air was filled with sulphuric fumes, and intense, white clouds of steam hissed up from the red-hot mafic lava streams, flowing at more than 1,000°C (2,000°F) into the cold Pacific Ocean. Andrew set up his shot about 20 metres (70 feet) from the lava, the soles of his shoes and the rubber spikes on his tripod melting from the intense heat. Using a long exposure to capture the motion of the incoming waves, he brought all the elements together to produce an image of a raw, evolving landscape.

**Nikon D600 + 70–300mm f4.5–5.6 lens at 180mm; 1/3 sec at f32; ISO 100; Gitzo tripod + Markins ballhead.**

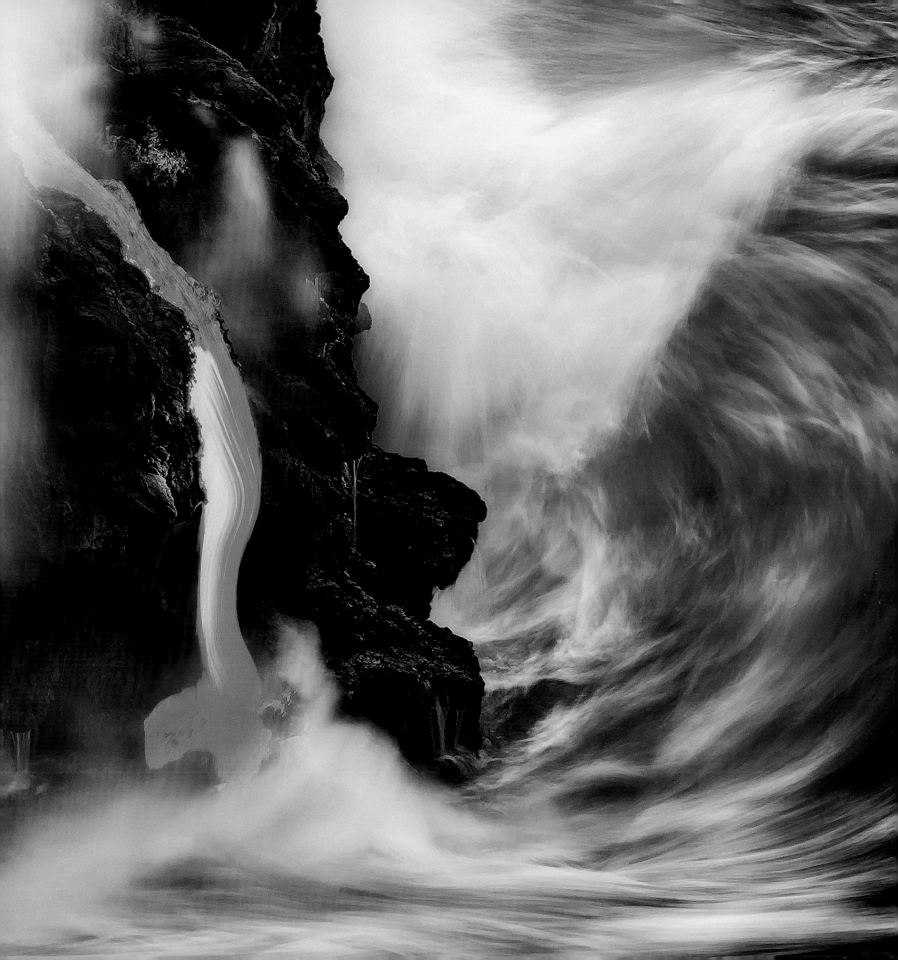

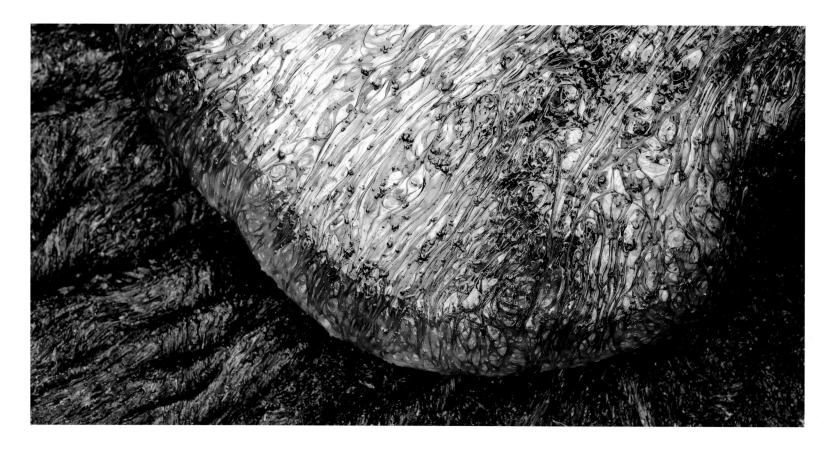

## A marvel of lava
### Bryan Lowry
USA

Getting to the lava flows of Kīlauea was a challenge – a long round-trip, starting out at night and carrying heavy kit. But it was routine for Bryan, who has been hiking over Hawaiian lava for the past 22 years, a devotee of the islands' volcanoes. This time it was raining and the thin pahoehoe lava, spreading in shiny sheets, was 'exceptionally clear and full of texture'. 'I was mesmerized by this small lobe,' recalls Bryan. Not having a macro lens with him, he needed to get up close. The vast flow was moving slowly, but at more than 1,000°C (2,000°F), it was radiating extreme heat. Bryan stood on the inflating lava near the flow edge, its surface cooled by rain. He bent his camera down using the tripod's closest leg and snapped the image via a cable remote. 'For a split second, the lens was a foot's length from the flow,' says Bryan. Though the camera was too hot to touch for several minutes after, the result was the abstract image he had hoped for.

**Nikon D800 + 50mm f1.8 lens; 1/60 sec at f10; ISO 400; Dolica tripod; cable shutter release.**

# Cool heat
## Juan Jesus Gonzalez Ahumada
SPAIN

Juan had marvelled at the pattern caused by the crack in a huge agave leaf. The succulent was growing near his parents' house in Sierra Blanca, southern Spain, and as the weighty leaf had grown it had curved over and started to split. Now it was about to be destroyed in a controlled burn, lit to prevent flash fires in summer. Struck by the contrast between the cool blue of the leaf and the warm light from the fire 'seeping through the wound', Juan had to work quickly. Its colour was darkening and its smooth texture deteriorating fast in the heat. He used a 'cool' white balance to enhance the leaf's blue tone and a flash from the side to emphasize the cracks and give more contrast in the early evening light, but he managed just a few shots before the effect he wanted – 'like a sheet of ice with fire below' – was spoiled by the blaze.

Canon EOS 7D + 100mm f2.8 lens; 1.6 sec at f8; ISO 100; Manfrotto tripod; flashlight.

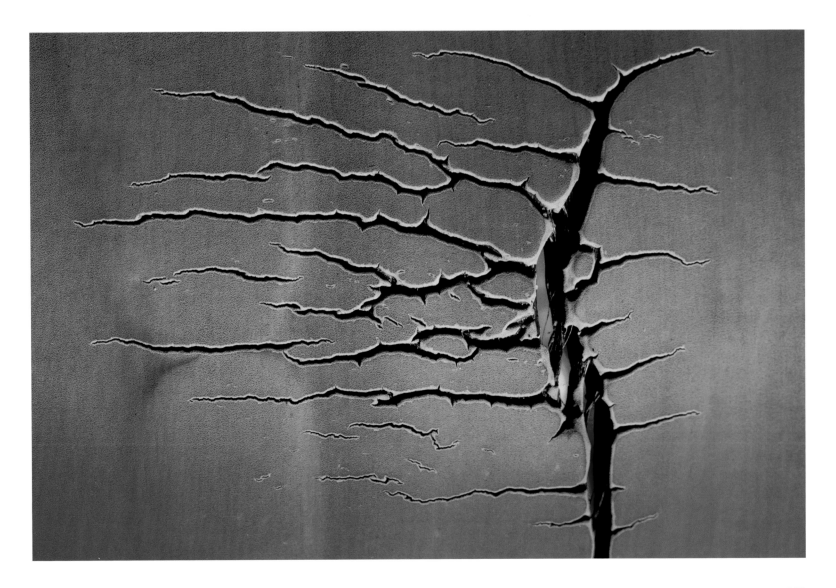

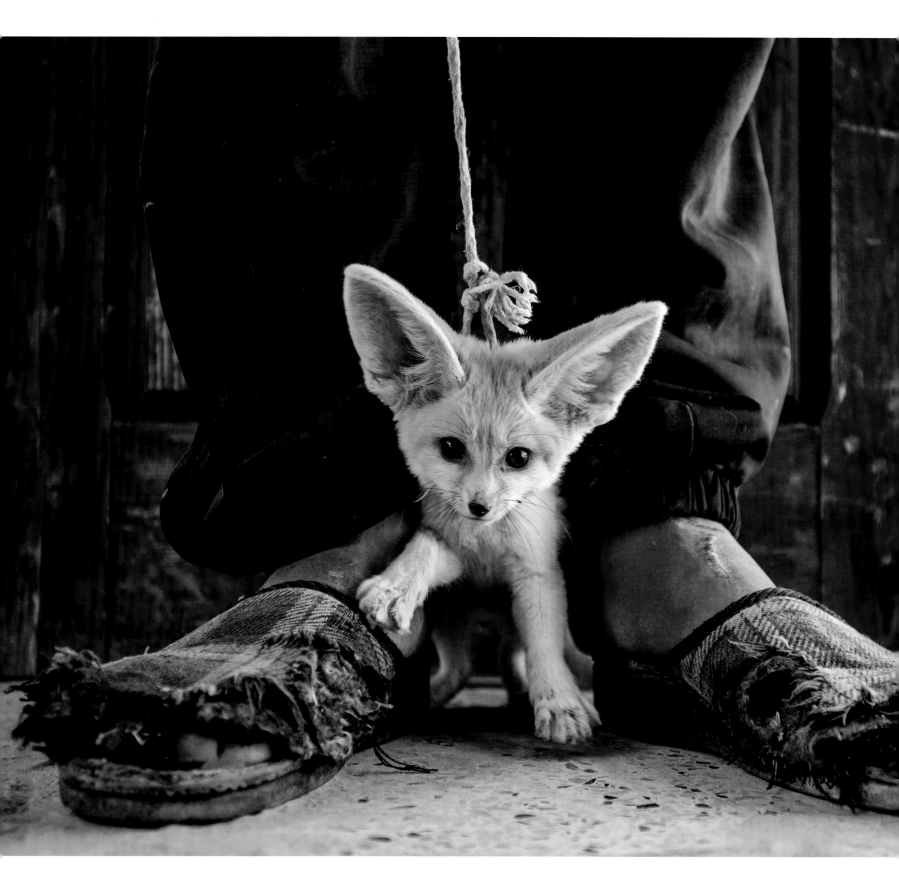

# World in Our Hands

## The price they pay

### Bruno D'Amicis

ITALY

A teenager from a village in southern Tunisia offers to sell a three-month-old fennec fox, one of a litter of pups he dug out of their den in the Sahara Desert. Catching or killing wild fennec foxes is illegal in Tunisia but widespread, which Bruno discovered as part of a long-term project to investigate the issues facing endangered species in the Sahara. He gained the confidence of villagers in Tunisia, Algeria and Morocco and discovered widespread wildlife exploitation, including hunting and capture for commercial trade and traditional medicine. He also discovered that the causes and therefore the solutions are complex and include high unemployment, poor education, lack of enforcement of conservation laws, ignorant tourists and tour companies, habitat destruction and the socio-political legacy of the 'Arab Spring' revolts. But Bruno is convinced that change is possible – that tourism has a part to play and that thought-provoking images can help raise awareness among tourists as well as highlight what's happening to the fragile Sahara Desert environment.

**Canon EOS 5D Mark II + 17–40mm f4 lens at 38mm; 1/160 sec at f4; ISO 400.**

# Hollywood cougar

## Steve Winter

USA

Los Angeles' Griffith Park, site of the iconic Hollywood sign, is not where anyone expected to find a cougar. But in March 2012, a trail camera set to monitor wildlife caught an image of a big male. Steve's excitement was as great as that of the biologists. Working with them, he set up a series of camera traps in the hills around Los Angeles, each positioned so they might catch the cougar against the city background. But it took 14 months before everything finally came together – the posture, composition and lighting – and he got his dream shot, the ultimate urban cougar picture. Extremely adaptable, cougars are now recolonizing areas in the USA where they've been hunted out. To get to downtown Los Angeles, the male would have had to travel at least 32 kilometres (20 miles) from the nearest California cougar population and cross two of the busiest highways in the USA. He has plenty of food – hunting deer, coyotes and raccoons in the canyons at night – and he continues to hide from people in the day. But in a human-dominated environment, he faces other trials. In 2014, he had to be captured and treated for both mange and rat-poisoning, and cars remain a constant threat.

**Canon EOS Rebel T3i + 10–22mm lens at 21mm; 4 seconds at f6.7; ISO 1600; waterproof camera box + Plexiglas tubes for 2-SB700 Nikon flashes; Trailmaster infrared remote trigger.**

# Where is my forest?

## Ian Johnson

SOUTH AFRICA

Without warning, the silverback mountain gorilla leapt over the stone wall and just stood there, on the boundary of the Volcanoes National Park forest. He and his family are effectively stranded in the park, which is ringed by farmland. About 480 mountain gorillas remain on the Virunga massif of Rwanda, the DRC (Congo) and Uganda, with just over 400 in the Bwindi park in Uganda. Conflict over habitat, along with the threats posed by oil and gas exploration, hunting and war mean their future is threatened. Here, at the foot of Mt Sabinyo, Rwanda, fields of potato and pyrethrum have replaced the forest. But inspired by rewilding projects elsewhere, Ian believes that, one day, if the needs of the people are met, it might still be possible to reforest areas adjacent to the parks and safeguard the gorillas' future.

**Nikon D3s + 70–200mm f2.8 lens; 1/800 sec at f5.6; ISO 1250.**

# The longline lottery
## Rodrigo Friscione Wyssmann
MEXICO

It had clearly been a monumental struggle: the young great white shark's jaw jutted out at an ugly angle, evidence of how it had fought to escape from the hook before finally suffocating. Rodrigo came upon the grim sight off Magdalena Bay on the Pacific coast of Baja California, Mexico, after noticing that a fisherman's buoy had been dragged below the surface by a considerable weight. The hook was on a long line of hooks, set to catch blue and mako sharks. 'I was deeply shocked. Great whites are amazing, graceful and highly intelligent creatures. It was such a sad scene that I changed the image to black and white, which felt more dignified.' Such surface-baited longlines may stretch for miles and are responsible for the deaths of tens of thousands of animals every year, many of them endangered.

**Nikon D300 + Sigma 15mm lens; 1/125 sec at f8; ISO 200; two Inon Z-220 strobes.**

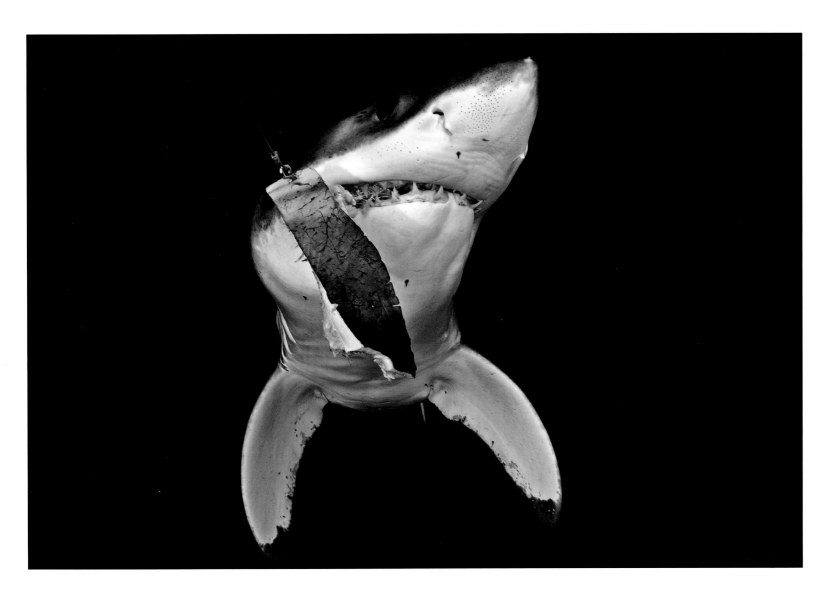

# Filthy riches
## Charlie Hamilton James
UNITED KINGDOM

Gold mining in the Amazon is increasing at a far more rapid pace than was previously thought. Charlie, who was in Peru to make a TV series about the Amazon rainforest and its associated problems, wanted to see for himself the full extent of the clandestine gold mining and took a flight over an area of forest not far from the Peruvian town of Puerto Maldonado. The landscape in the gold-mining area was, he said, 'devastated'. Gold mining is closely linked to gold prices, and after the global economic recession in 2008, the average annual rate of forest loss is estimated to have tripled. Large amounts of mercury, used during mining to concentrate the gold, has also bled into rivers, causing significant problems for the environment and for local people – many have five times the safe limit of mercury in their bodies. Most of the gold mined from areas such as Peru ends up in banks – the Bank of England alone has some 4,600 tonnes of gold in its vaults.

**Canon EOS-1D X + 24–105mm lens; 1/2000 sec at f6.3; polarizing filter; ISO 800.**

## Dinner at the dump

### Karine Aigner

USA

In parts of Ethiopia, where there is little wild prey left for predators to hunt, spotted hyenas, intelligent opportunists, have learned to make do – in fact, to thrive. Every night, in the northern city of Mekelle, hyenas converge at the city dump to feed on anything organic, including bones and rotting meat. The locals tolerate the hyenas, grateful for these 'municipal workers' and their heavy-duty digestive systems. During Lent, though, the hyenas' behaviour changes. Ethiopia's Orthodox Christian Church requires people to fast for 55 days, with the result that the amount of food at the dump all but vanishes. The hungry hyenas, ever-adaptable, switch to hunting livestock, including donkeys and the occasional dog. Despite their losses, the locals still tolerate them. Come Easter, humans and hyenas revert to their normal diets. After hearing this story, Karine determined to photograph the scene. The hyenas would arrive like clockwork after sunset, but the landscape would alter, depending on how much rubbish was dumped. So every night Karine had to reposition the strobes, then locate the animals in the dark so she could trigger the camera. A week later, she got her shot – and learnt a lesson: never leave a rubber-covered mini-tripod in a hyena dining area. Hyenas eat rubber and can crunch metal. She retrieved the remnants of the GorillaPod and strobe the next day, crushed and useless.

**Canon EOS 5D Mark III + 16–35mm f2.8 lens; 8 sec at f8; ISO 1250; three Canon 580EX strobes; three PocketWizard transmitters; one PocketWizard receiver; PocketWizard remotes.**

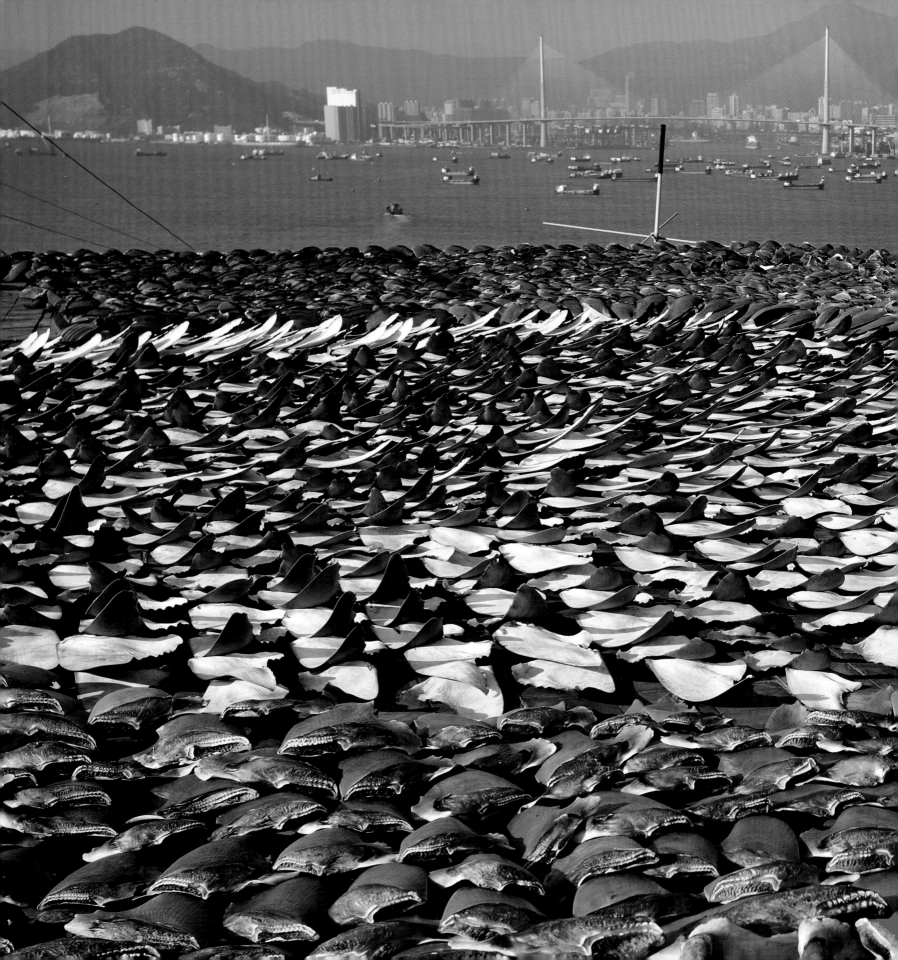

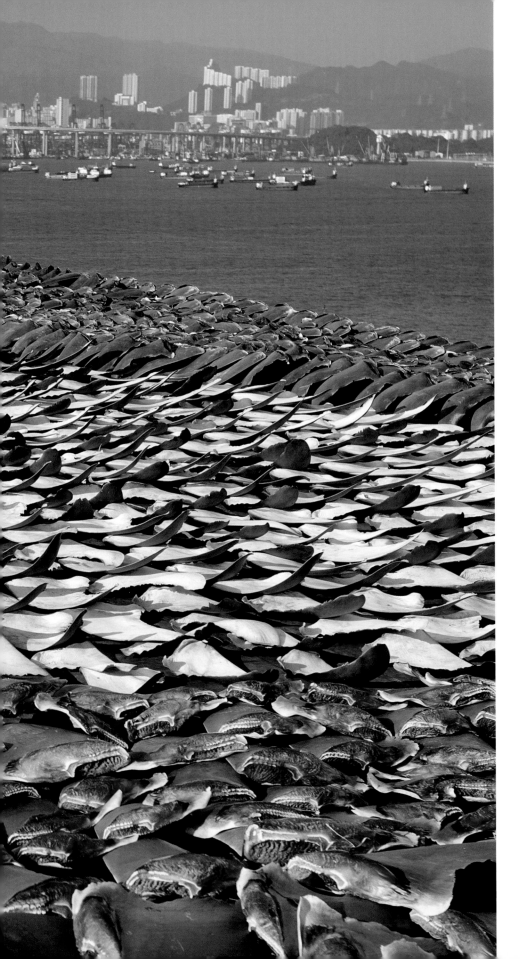

## Sea of death
### Paul Hilton
UNITED KINGDOM/AUSTRALIA

A sea of fins covers the roof of a building in Hong Kong – representing the slaughter of some 30,000 sharks. Roofs are now where the traders dry the shark fins, following a public outcry over the growing volume of fins being dried on public pavements. The picture was taken as part of Paul's reportage of the worldwide slaughter of sharks for their fins. The most reliable median estimate of the global fishery catch is about 100 million sharks every year, and the catch could be as high as 273 million sharks per year. Most species targeted are large animals and slow to reproduce, and their reproduction rates cannot match the numbers being killed. While shark parts sold include meat, skin, teeth, jaws and oil, it has been the high market value of shark fins, chiefly in Hong Kong and China, that has driven the demand. Of the 14 shark species most traded, more than 70 per cent are classified as endangered or vulnerable, meaning they are at a high or very high risk of extinction in the wild. Yet in a new report, traders cited declining prices, with one quoted as saying: 'On the street, shark fin is now the same price as squid.'

**Canon EOS 5D Mark III + 16–35mm f2.8 lens; 1/400 sec at f10; ISO 400.**

# The Wildlife Photojournalist Award

The challenge here is to tell a story with just six images. The six are judged on their story-telling power as a whole as well as their individual quality.

## Brent Stirton

SOUTH AFRICA

## WHAT FUTURE FOR LIONS?

The lives of lions are now inextricably linked to those of humans. This portfolio highlights some of the ways in which humans regard lions and utilize them. At one extreme is 'canned-lion' hunting, where lions are bred on farms specifically to be killed by wealthy hunters and their bones exported to Asia. Elsewhere in Africa, where the risk of a lion attack is a reality, communities are finding ways to live alongside these predators and may even engage in conservation initiatives. Lion conservation is a subject riddled with ethical and practical challenges, conflicts and compromises, all within the wider contexts of habitat loss and global economic and political pressures. The fact is, though, that lion numbers continue to fall and that the species faces a high risk of extinction in the wild.

## Bred to be killed

A captive-bred lion snarls at the manager of a lion-breeding farm in South Africa. Lions are raised to maturity and, when they're old enough (about seven), sold to hunters to be shot in special enclosures. It is legal, though highly controversial. Some argue that lion farms (there are probably around 170–200 in South Africa) are necessary components for the survival of lions as they decrease the hunting pressure on wild populations, serve as DNA banks and could one day repopulate areas where lions have been wiped out. Critics question the validity of some of these claims and raise concerns about the ethical and welfare issues.

Canon EOS-1D X + 24–70mm f2.8 lens at 24mm; 250 sec at f16; ISO 320.

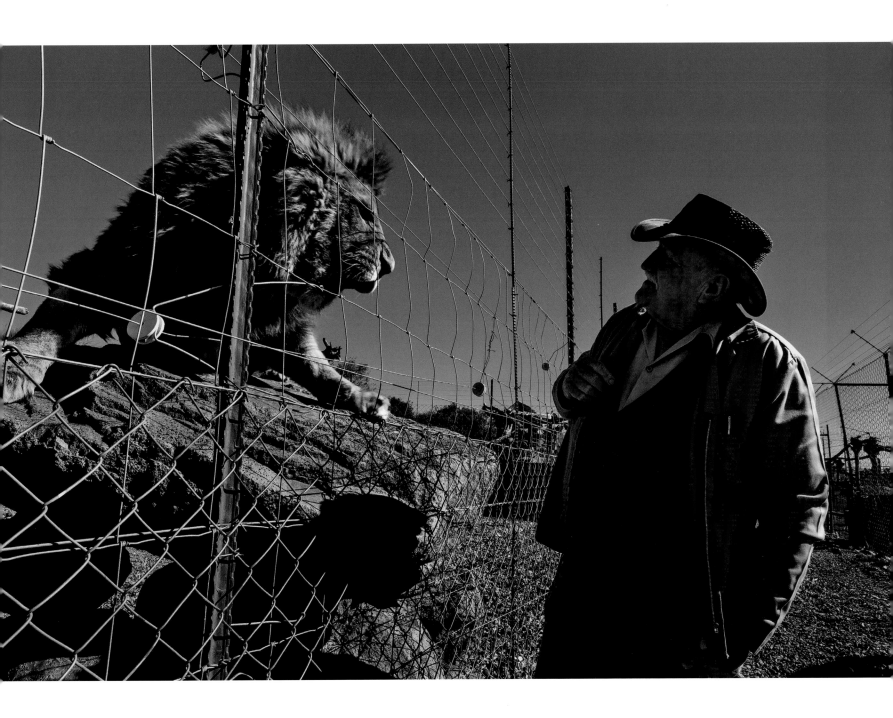

## Value choice

An American trophy hunter takes aim with a bow at a 'canned' lioness on a game farm in South Africa, while professional guides stand ready with guns in case things go wrong. He is just one of several thousand hunters – mostly from the US, but from Russia and Europe, too – who travel to Africa every year, paying on average $20,000–$40,000 (though it can be as much as $200,000) to kill a lion. Trophy hunting generally is a major industry in Africa, with more land given over to hunting concessions across the continent than covered by national parks. Hunting advocates argue that trophy hunting creates incentives to help conserve land that might otherwise be put to less-conservation-friendly use. 'We're moving into a space where many people believe that an animal has to have economic value,' says Brent, 'and that means either ecotourism or hunting.'

**Canon EOS-1D X + 24–70mm f2.8 lens; 1/250 sec at f16; ISO 320.**

## Trophies and trade

A worker cleans the skin from a freshly shot lioness. Proponents of canned-lion hunting argue that the trade employs local people and also indirectly generates employment through the supply of periphery services such as hotels, catering, entertainment and transport. The American hunter who paid to shoot the lioness will legally take her skin and skull home as trophies. The bones will be sold separately and exported to the Far East for use in traditional Chinese medicine. This legal trade, though, has triggered a dramatic increase in the illegal trade in lion bones, especially now that tiger bones are increasingly scarce. As the number of wild tigers dwindles, critics argue that this trade will increase demand for the bones not only of wild lions but potentially also of other felids, and that the illegal traffickers are the same as those poaching ivory and rhino horns.

**Canon EOS-1D X + 24–70mm f2.8 lens; 1/250 sec at f14; ISO 320.**

## Choreography of the kill

Lion dancers from the Sakuma tribe perform the story of their lion-killing outside a village in western Tanzania. Traditionally, these are men who have killed a lion in defence of their cattle or their village. The Sakuma are deeply superstitious and believe that once a man has killed a lion, he must become a lion dancer for three to five years to avoid going mad. The dancers spend a year or more preparing with the local witch doctor and then go from village to village collecting tributes (money, goats or even a cow) in praise of their bravery. These rewards mean that killing a lion is something that some young men aspire to, even going so far as to venture into the local Katavi National Park in pursuit of a lion that has done nothing to threaten them. Lions are increasingly scarce around here, and this practice is actively discouraged by conservation organizations and is now slowly dying out.

**Canon EOS-1D X + 24–70mm f2.8 lens; 1/250 sec at f4.6; ISO 320.**

## Living with lions

Yusuf Shabani Difika, 41, can no longer hold his two young children and depends on his uncle to wash him. He was fishing on the border of Selous National Park, Tanzania, when a lion attacked. Friends drove off the lion, but Yusuf had to have what was left of his arms amputated. He now relies entirely on his family to eat, drink and get dressed, and on the rest of the village for other support. Lions often range beyond the park boundaries, and people are especially vulnerable during harvest, when they sleep in their fields to protect their maize and rice crops from wild bush pigs, which in turn attract lions.

**Canon EOS 5D Mark III + 24–70mm f2.8 lens; 1/250 sec at f4.5; ISO 160.**

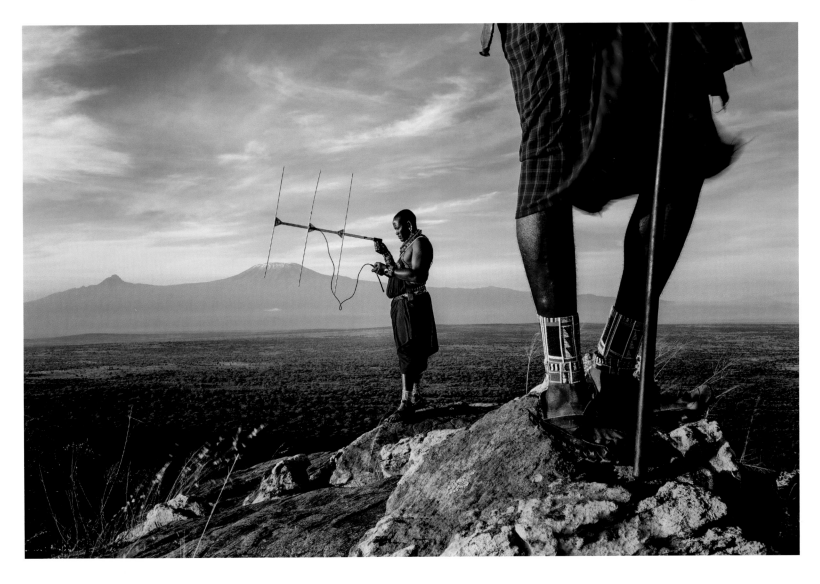

## Lion guardians

Maasai Lion Guardians tracking radio-collared lions. Retaliatory and traditional spearing by Maasai warriors is the greatest threat to the survival of lions in southern Kenya. The Lion Guardians conservation programme recruits Maasai men, many former lion-killers, into a system that monitors lions, confers a sense of ownership and pride in them and forms a vanguard to prevent other Maasai from hunting lions in retribution for cattle-killing. The guardians track the lions and collect DNA samples for analysis. They have named all the lions in their area and have produced identity cards, which further reinforce notions of lion identity within Maasai communities.

**Canon EOS 5D Mark III + 24–70mm f2.8 lens; 1/30 sec at f22; ISO 160.**

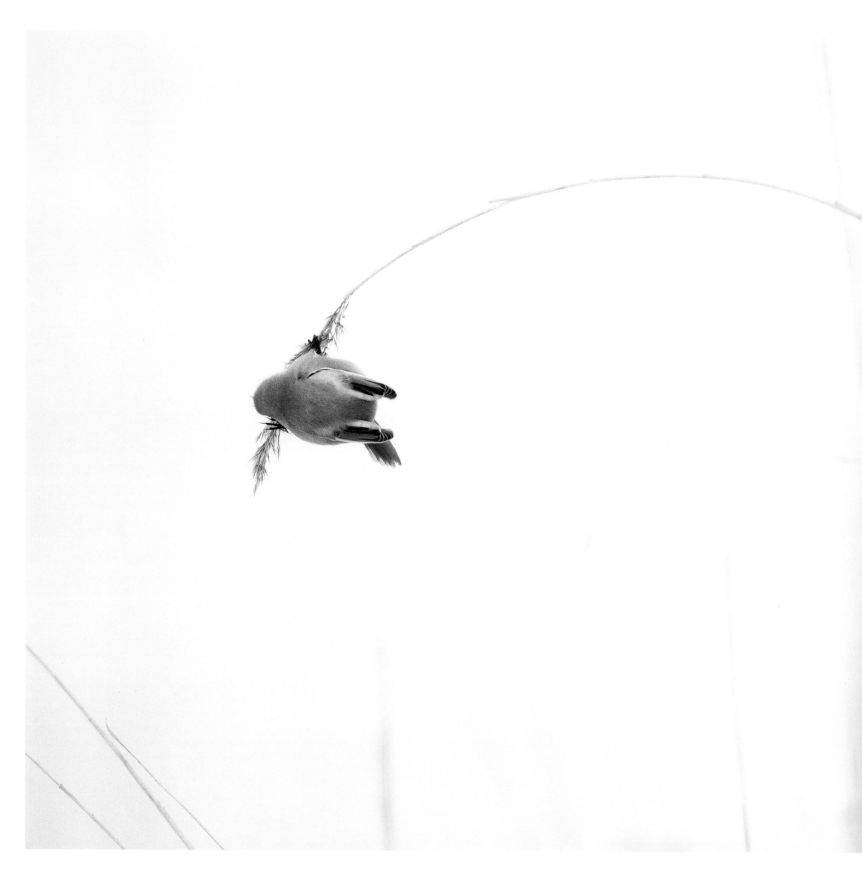

# The Rising Star Portfolio Award

This award seeks to inspire and encourage photographers between the ages of 18 and 26 and is given for a portfolio of work.

## Michel d'Oultremont

BELGIUM

It was a TV programme about nature photographers that inspired Michel, at 15, to take up photography seriously. 'When I first started out, there were a couple of times when I disturbed animals by trying to get too close,' he remembers. 'These incidents upset me greatly. So I made a commitment never to let that happen again.' It's an ethos that shines through his work. 'I try to photograph the environment first, along with animals that happen to live in it, pass through it or engage with it. I want to take pictures that do justice to the emotion that this generates for me and in this way helps raise awareness of the beauty of nature and the importance of conservation. That's what's closest to my heart.'

## Feather heavy

In winter, when there are few insects about, bearded tits are forced to feed mainly on reed seeds. Michel heard that a flock of them had congregated in a reedbed near Rotterdam and that the water on the lake had frozen. As he walked out into the reedbed, he could hear the reedlings' clear 'ping' calls, but the tiny birds were difficult to see. When one started feeding on a reed head, the wind would blow other stems into the frame, making it almost impossible to get a clean image, and if a stalk was slender, the weight of the reedling's tiny body would make it bend over in an arc and bob in the wind. This shot was one of the rare moments when the view was clear, the reed stopped bouncing and the colours of the male's beautiful plumage were in full view.

Canon EOS 5D Mark III + 500mm f4 lens; 1/2000 sec at f4.5 (+2 e/v); ISO 800; Feisol Elite CT-3372 tripod.

## The marsh at dawn

Michel arrived at this wetland in the Netherlands about three hours before dawn. It's one of his favourite places – 'my little corner of paradise'. He knows it so well that he can sort out his equipment and slip into the water in his floating hide even in complete darkness. He stays in one place until the light starts to seep into the marsh and the birds start to stir. In this picture, the sun hasn't risen but a black-necked grebe is already paddling off to fish, oblivious to Michel's presence. 'I love using the floating hide. It allows me to be so quiet and unobtrusive – it's an intense way to work.' He kept the grebe very small in the frame, partly to portray a feeling of wilderness and partly because the composition was as much about the layers of shape-shifting vegetation as it was about the grebe.

Canon EOS 5D Mark III + 500mm f4 lens; 1/250 sec at f4 (+0.6 e/v); ISO 2500; hide.

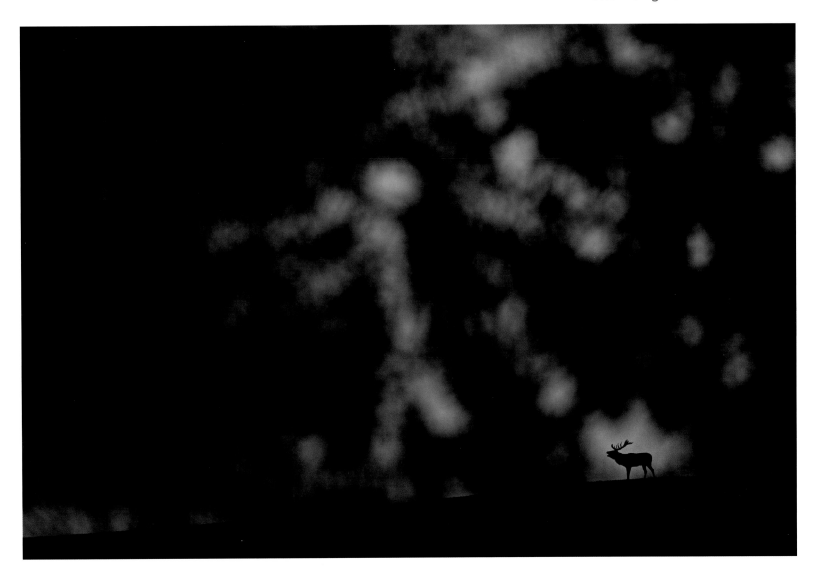

## Forest stag

It was early evening, and the rutting stag had been bellowing for hours in the woods. Michel was in his hide down by the river, with a view across the meadow where the red deer hinds were. But it was only just as the light was beginning to fade that he saw the stag as it emerged onto the crest of the hill, its roars reverberating across the valley. Michel took a series of shots, but he thought they looked unoriginal and didn't capture the atmosphere. Then inspiration struck. Creeping out of his hide so the stag wouldn't see him, he waded slowly into the river and crouched in the cold water behind a pile of leafy branches that had become trapped in the middle of the river. With this natural prop, he now had the tapestry of light, shade and pattern to create the atmosphere he wanted.

**Canon EOS 5D Mark III + 500mm f4 lens; 1/2000 sec at f4.5; ISO 400.**

## Frozen repose

Belgium doesn't usually suffer cold winters, but the winter of 2012–13 was exceptionally bitter. After an unsuccessful morning trying to photograph hares in the snow, Michel was driving home, keen to get warm. But out of the corner of his eye he spotted the hunched shape of a buzzard perched in a tree beside the road. It was a perfect photographic opportunity. The buzzard was immobilized by the cold, the camera was ready on the passenger seat – on the right settings – and Michel had stopped the car in exactly the right position to be able to include the mesh of frost-covered branches and twigs in his image of the freezing reality of the bird's world. He didn't even have to open the window.

**Canon EOS 5D Mark III + 500mm f4 lens; 1/2000 sec at f8 (+0.6 e/v); ISO 500.**

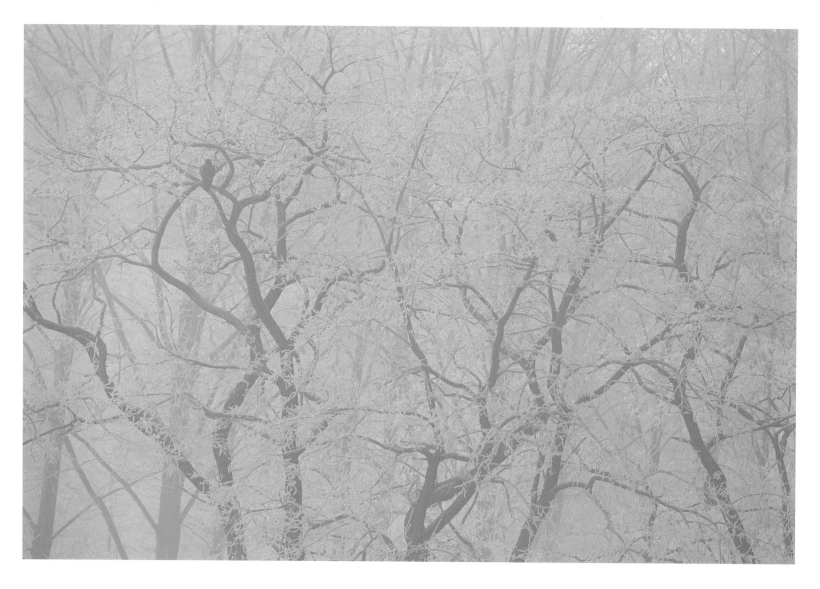

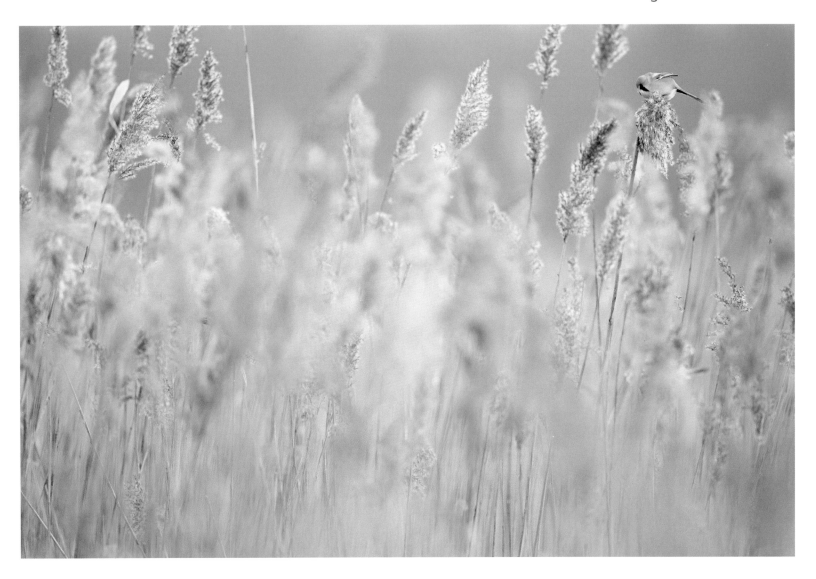

## Reed pastels

Rather than take close-ups of the bearded tits feeding in the reeds, Michel decided to pull back out to a wider view of the reedbed and experiment with the textures and colours. The water of the lake, near to Rotterdam, had frozen, allowing him to set up his tripod at the edge of the reedbed. The movement of the fluffy seed heads, blown by the wind, became part of the composition and, in the winter light, enhanced the harmony between the colours of the sky and reeds and the grey and orange plumage of the little male.

**Canon EOS 5D Mark III + 500mm f4 lens; 1/500 sec at f5 (+0.3 e/v); ISO 800; Feisol Elite CT-3372 tripod**.

## Dusk transition

Michel loves the effects of light on water, and especially the strange light to be found in the transition between day and night. On this evening, he lay in his floating hide, at eye level with the water, keeping the vegetation between himself and the setting sun, and played with the effect of silhouettes and the fat pearls of reflected light. It all came together in the moment before the sun set, when a black-necked grebe swam into view on the horizon and completed the picture.

**Canon EOS 5D Mark III + 500mm f4 lens; 1/4000 sec at f4; ISO 400; aquatic hide.**

# The Young Wildlife Photographer of the Year 2014

The Young Wildlife Photographer of the Year 2014 is Carlos Perez Naval – the winning photographer whose picture has been judged to be the most memorable of all the pictures by photographers aged 17 or under.

## Carlos Perez Naval

SPAIN

**Carlos has been taking photographs seriously for the past three years (since he was five) and has already won prizes in Spanish, Italian and French competitions. He loves nature, whatever and wherever it is, and spends as much time as possible out photographing the plants and animals around his home in Spain.**

**WINNER (10 YEARS AND UNDER)**

## Stinger in the sun

Aware of Carlos's presence, the common yellow scorpion is flourishing its sting as a warning. Carlos had found it basking on a flat stone in a rocky area near his home in Torralba de los Sisones, northeast Spain – also a place that he goes to look for reptiles. The late afternoon sun was casting such a lovely glow over the scene that Carlos decided to experiment with a double exposure (his first ever) so he could include the sun. He started with the background, using a fast speed so as not to overexpose the sun, and then shot the scorpion, using a low flash. But he had to change lenses (he used his zoom for the sun), which is when the scorpion noticed the movement and raised its tail. Carlos then had to wait for it to settle before taking a close-up, with the last rays of the sun lighting up its body.

**Nikon D300 + 105mm f2.8 lens (28–300mm lens for the background); 1/320 sec at f10; ISO 320; flash.**

## Cranes at dawn
### Leon Bohlmann
GERMANY

Like trumpets – that's how Leon describes the haunting calls of common cranes. To photograph them, he and his dad got up while it was still dark and crept into a hide on the shore of Lake Galenbecker in northern Germany. The lake is a staging post for migrating waterfowl, including thousands of common cranes. On this morning, a wall of mist rose up over the lake at sunrise, and for a while, Leon could barely see anything. Then, for a short moment, the mist dissipated, just as a group of cranes flew by. Leon focused on the submerged trees to help keep the birds sharp as the early morning sun bathed the lake in gold.

**Nikon D7000 + 70–200mm f2.8 lens + 2x teleconverter; 1/1600 sec at f6.3; ISO 500.**

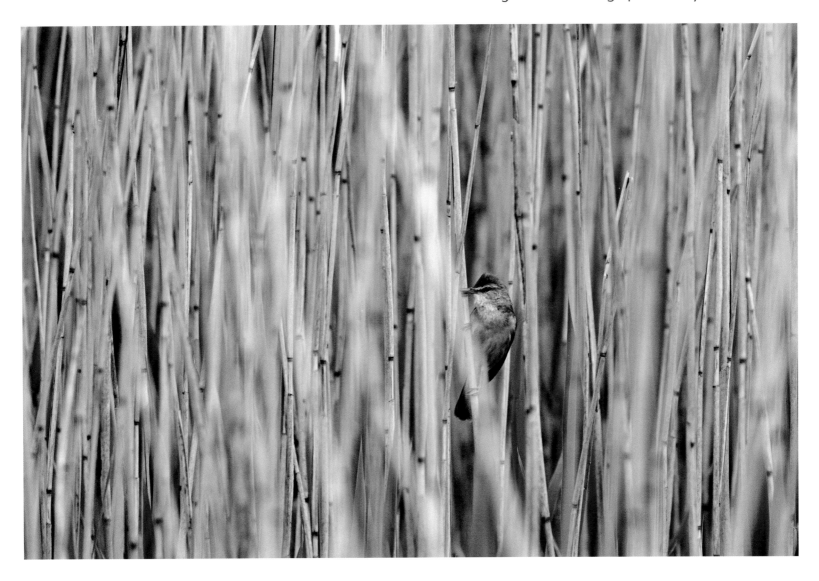

## Little big voice
Leon Bohlmann

GERMANY

A bird flying among the reeds caught Leon's eye – and his ear – as he rowed with his family along the edges of Lake Lübkow in northern Germany. It was a great reed warbler, loudly declaring his territory. Leon asked his parents to drop him off on a wooden pier nearby, where he stayed watching for the bird while they went off to fish. It was a real test of patience. Though Leon could hear the distinctive calls of 'the boss', as he called him, proclaiming his territory among the reeds, it was a long time before the male showed himself, and then only briefly, giving Leon just one chance to get his shot.

**Nikon D7000 + 70–200mm f2.8 lens + 2x teleconverter; 1/1250 sec at f5.6; ISO 800.**

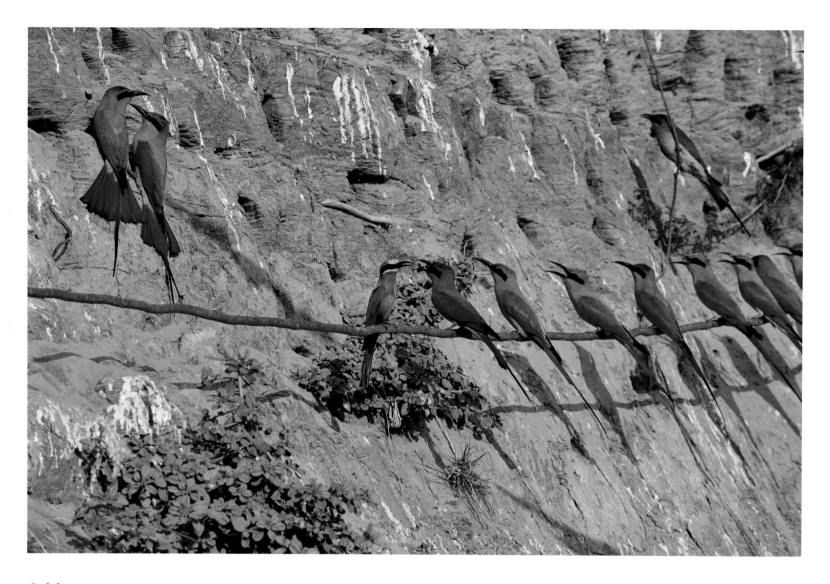

## Odd one out

Daniel Back

UNITED KINGDOM

When Daniel visited the South Luangwa National Park in Zambia, his dad lent him a camera. One evening, from a small hide, Daniel practised photographing the carmine bee-eaters flying in and out of their nests in the riverbank. It wasn't easy as the birds zoomed in and out at speed, and he just couldn't freeze them in flight. So he concentrated instead on the birds perched on a vine. In the midst of all the flutter and noise, he realized that a different species – a white-fronted bee-eater – had begun to fly in and out of the frame. It landed briefly on the vine, just long enough for Daniel to press the shutter. It wasn't until he got home that he realized that, on the lookout for insects flying above the water, it was facing in the opposite direction from the carmines.

**Nikon D5100 + Sigma 50–150mm f2.8 lens; 1/3200 sec at f7.1; ISO 1600.**

# The watchful cheetah
## Leon Petrinos
GREECE

Leon worked out how to use a telephoto lens thanks to his dog Scooby. His dad would throw a tennis ball and, as Scooby raced after it, Leon would try to get the shot. They practised, and by the time Leon went on his first safari in the Maasai Mara in Kenya, he was ready. One evening, on the drive back to camp, they saw the cheetah. She had just finished eating an impala and was lying in the grass. Most people climbed on the roof, but Leon, then eight, was able to squeeze through the small side window and get a view almost at ground level. Though full and relaxed, the female was alert for danger, not least because she had a cub nearby and her kill might attract lions or hyenas. 'You can tell the animal's feelings from the look in the eye, the way the fur lies and the ears move,' says Leon. He particularly likes portraits, he says, because 'the animal's feelings talk to you'.

**Nikon D800 + 200–400mm f4 lens; 1/640 sec at f6.3 (-0.3 e/v); ISO 1600; beanbag.**

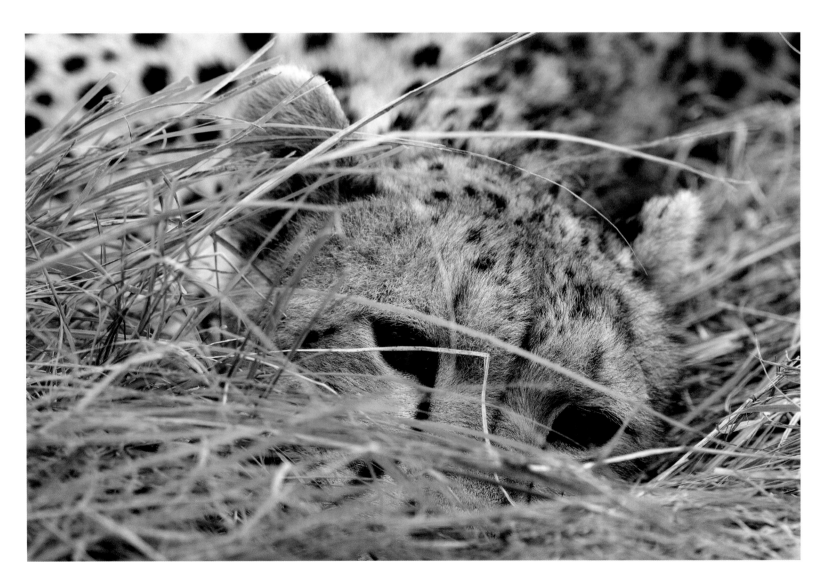

# Young Wildlife Photographers
## 11–14 years old

## Angle poise
### Marc Albiac

SPAIN

If the praying mantis moved, Marc knew he might never find it again, so good was its camouflage. He'd been helping his grandmother tidy up her garden in Barcelona, Spain, when he spotted the conehead mantis among the brambles. Though he's been taking wildlife photos for eight years, he'd never seen a conehead before and was desperate to photograph it, but he hadn't got his camera. There was only one thing for it. Leaving grandma with strict instructions not to let the creature out of her sight, Marc rushed home and got his equipment. But the mantis blended so well with the background and the light was so low, that his first pictures failed to show the exquisite detail of the animal. Then he had brainwave. Careful not to scare his subject, which kept an eye on him all the time, he taped up a sheet of white paper behind it, and bounced one flash off the paper itself, revealing the insect's extraordinary shape, colour, posture and behaviour in the perfect portrait.

**Canon EOS 5D Mark III + 100mm f2.8 lens; 1/100 sec at f18; ISO 320; one 580 EXII flash + two 430 EXII flashes; tripod.**

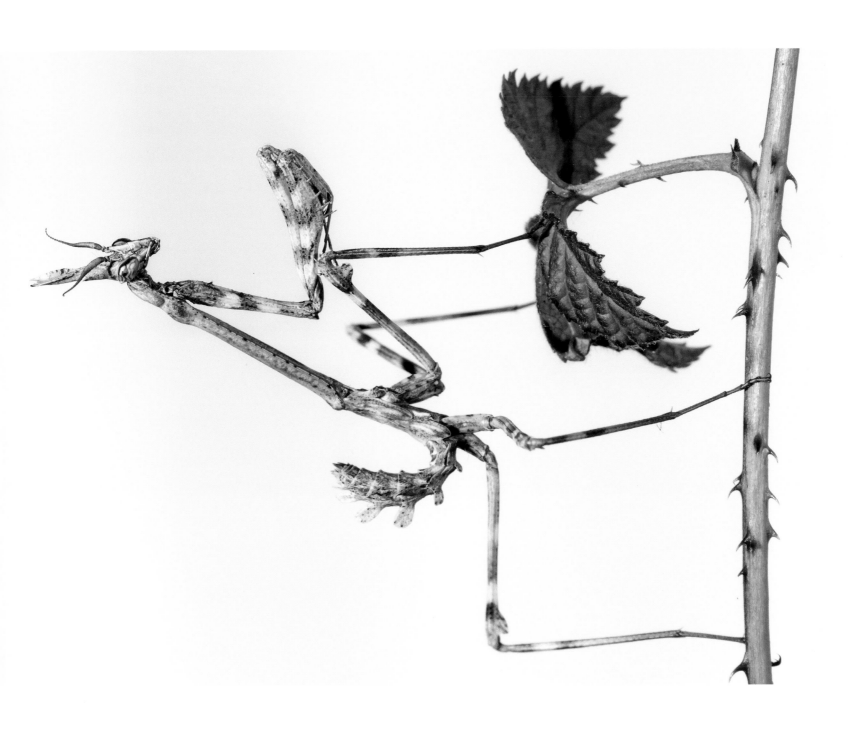

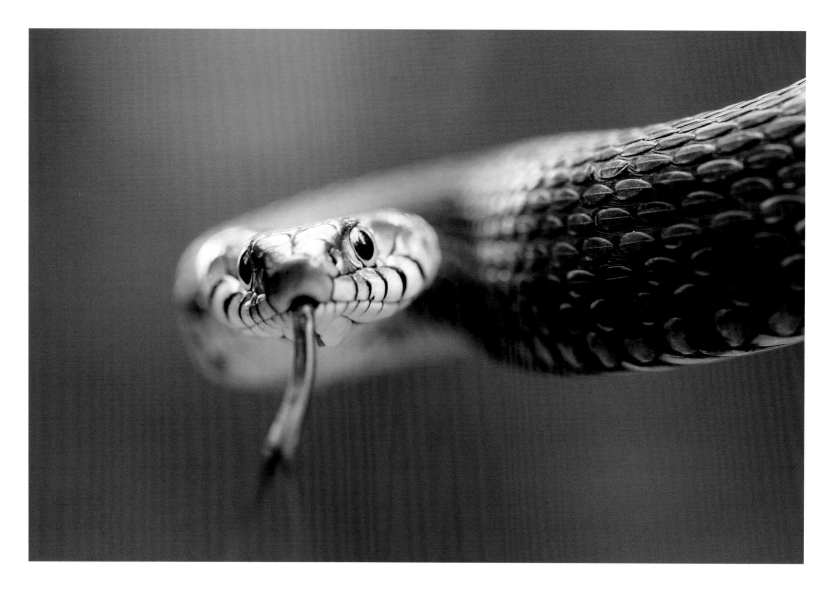

# Snake-eyes

## Marc Montes

SPAIN

Marc was trekking through the forest in the Val d'Aran, near his home in northern Spain – as usual, carrying his camera and keeping a lookout for animals – when he was thrilled to come across a large grass snake. 'I have a great passion for reptiles, especially snakes,' he says, 'and it is rare to see this kind where I live.' The grass snake, just over a metre (3 feet) long, was very alert and started moving, and the light was very poor. So Marc had to use a wide aperture, giving him only a very narrow depth of field (the depth that would be in focus). But though he had only a moment to compose the picture, he had the skill to take a portrait with the focus on the key part of the snake – its eyes.

**Canon EOS-1D Mark IV + 100mm f2.8 lens; 1/250 sec at f4.5; ISO 800.**

# Green dragon

## Will Jenkins

UNITED KINGDOM

Relaxing by the hotel at the end of a Costa Rican family holiday, Will was planning on a day hanging out by the pool and surfing – that was until the green iguana jumped down from the hotel roof. Will grabbed his camera. 'I love stories about dragons, and I wanted a big picture for my wall that would make me smile every day,' says Will. 'I also wanted to impress my dad and brother with a shot of the biggest iguana I'd ever seen.' The metre-long (3-foot) lizard made its way to the top of a rock. Will edged closer. 'I tried to keep in the shadows, hiding behind one sunbed and then the next, so as not to scare it.' Selecting a wide aperture to make his subject stand out, Will carefully focused on its eye. 'The iguana sunbathed for about 20 minutes before heading to the beach. It made me realize that you should always have your camera with you, just in case.'

**Canon EOS 5D Mark II + 70–200mm f2.8 lens at 200mm; 1/200 sec at f4; ISO 100.**

## Vanishing lions
### Skye Meaker
SOUTH AFRICA

Skye was on an afternoon game drive with his family in Kenya's Maasai Mara, when he spotted two young male lions lying in the grass. Trying out a new technique, he steadied his camera on a beanbag, focused on the nearest lion and, just as he pressed the shutter, zoomed the lens out, adding flash to highlight the eyes. 'It was tricky to move the lens at precisely the right moment and just enough to get the blurred effect, but not so much as to lose the lion's face,' he says. His perseverance eventually paid off, giving him the shot he had in mind. 'I want the picture to raise awareness that lions are a vulnerable species,' he says (numbers are thought to have decreased by a third over the past two decades). 'To me, this picture conveys the feeling that lions are fading from Africa.'

**Canon EOS 7D + 100–400mm lens at 400mm; 1/30 sec at f22 (+0.7 e/v); ISO 800; Speedlite 580EX II flash; beanbag.**

## Sunset reflection
### Tristan Moës
BELGIUM

Sitting alone beside a waterhole in Etosha National Park, Tristan waited. It was the dry season, cool and quiet. He was lucky enough to be spending three weeks in Namibia with his family on his first photographic trip. They'd come to this waterhole to photograph wildlife coming to drink at sunset. 'I love colour, silhouettes and low light,' says Tristan. 'And all these elements came together,' just as the giraffe and the black-backed jackal lined up in front of him, providing the perfect serene composition. As the jackal paused, ears back listening, Tristan adjusted for the low light and framed the image. The moment passed, the light went and the animals moved off. But Tristan had a special image to show his father, who from his viewpoint, hadn't even seen the jackal.

**Canon EOS 550D + 28–135mm f3.5–5.6 lens at 85mm; 1/4 sec at f5.6 (-2.6 e/v); ISO 100; Velbon Sherpa 450R tripod.**

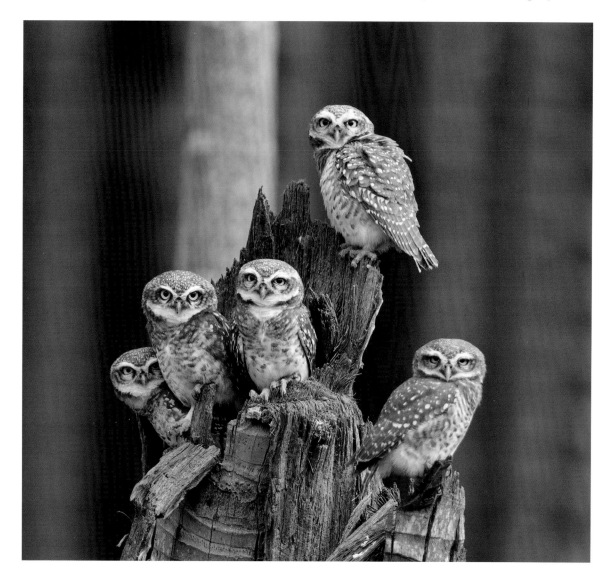

## Owlets united

### Sitara Karthikeyan

INDIA

When photographing waterbirds by a coconut grove in southern India, Sitara was excited to spot three spotted owlets perched on a dead tree, preening one another. When a few mynas started to mob them, the owlets let out a shrill call, whereupon two adults joined them and all five stood their ground. 'I was moved by their togetherness when in danger,' says Sitara, 'and I wanted to capture the feeling.' To get an eye-level shot, she was forced to abandon her tripod and hand-hold the camera – 'challenging,' she says, 'as the lens was so heavy'. Selecting a wide aperture to blur the background, she focused on the owls. Then, at the first click of the shutter, they all looked her way.

**Canon EOS-1D Mark IV + 300mm f2.8 lens + 2x extender; 1/400 sec at f5.6 (-0.7 e/v);**
**ISO 640; Benro tripod + Jobu Design gimbal head.**

# Young Wildlife Photographers
## 15–17 years old

### The long embrace
Anton Lilja

SWEDEN

The moment her eggs make contact with water, the jelly around them will begin to swell. So a female frog needs to have a male nearby, ready to fertilize the eggs the instant they leave her body. And a male needs to hold on to her to make sure he's the one doing the fertilizing. So he grasps her in a tight embrace, known as amplexus, often for days, until she has laid her eggs. Hearing that masses of common frogs were gathering in a flooded gravel pit near his home in Västerbotten, Sweden, Anton set out to photograph the mating spectacle. Lying down on the bank at eye level with the water, he became fascinated by the light bouncing off the spawn and the water, which by now was vibrating with the activity of the frogs. Experimenting with his flash, he achieved the effect he wanted just as a pair of frogs in amplexus popped up right in front of the camera, the male revealing his throat to be flushed with blue. They stayed posed amid the glossy wobbliness, allowing Anton time to compose his shot.

Nikon D2X + 70–200mm f2.8 lens + 1.4x teleconverter; 1/500 sec at f6.3; ISO 200; Nikon SB-800 Speedlight flash.

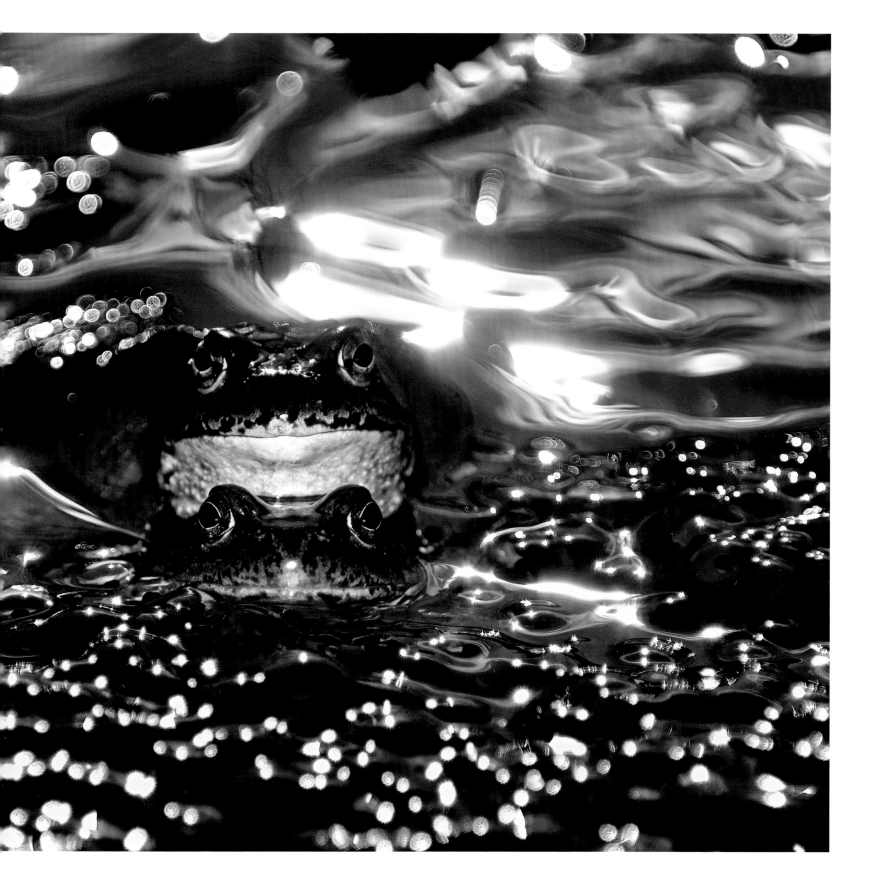

# Fish-eye view

## Joshua Burch

UNITED KINGDOM

Eyes bulging, the heron stared down at Joshua, and for a second Joshua stared right back. Looking up, it was easy to imagine what it might be like to be a fish, with that deadly beak about to strike. It was one of those truly serendipitous moments. Joshua had wandered down to the Pen Ponds in Richmond Park, London, home to a handful of grey herons. A scuffle had broken out between two males, and Joshua had watched as one heron began to chase the other around the lake, driving it off the water and into the tree Joshua was standing under. In fact, the heron landed right above his head. Seizing the moment, Joshua lifted his camera and lens off the tripod and shot up through the branches, catching the moment the heron turned its attention to him. It was, he said, 'amazing to see such a common bird in a completely new way'.

**Canon EOS 7D + 400mm f2.8 lens; 1/1600 sec at f4; ISO 500.**

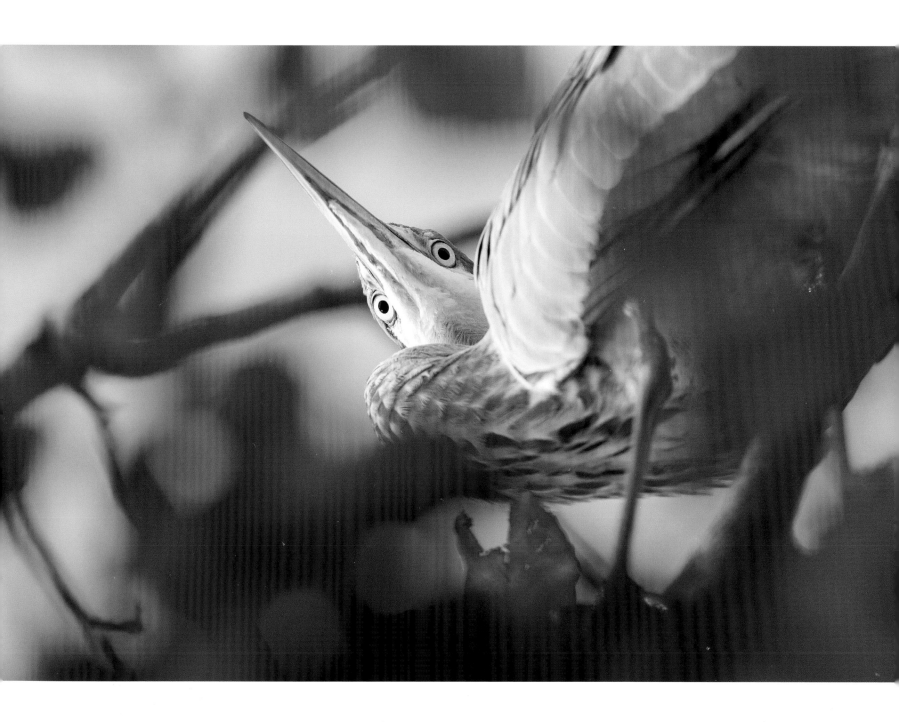

# The resurrected forest
## Ingo Zahlheimer
GERMANY

In 1990, an infestation of bark beetle destroyed vast areas of managed spruce forest in the Bavarian Forest Biosphere Reserve. The authorities decided to let nature take charge, leaving infested trees standing and stopping all logging in the area. By the time Ingo took this image, nearly a quarter of a century later, the results were clear: the forest was rejuvenating. Now it has a mosaic of species, including rowan and a carpet of reed grass, and spruce of different ages, which is far more likely to survive future beetle infestations. Ingo climbed the slopes of Mt Lusen on the German-Czech border, to take a picture, looking down on the trees. He chose a rainy day in autumn – 'the colours come out more brilliantly if everything is wet.' Ingo loves the remoteness of the area and considers the regrowth of 'new life from dead matter one of the most amazing natural spectacles in the world'.

**Nikon D700 + 300mm f4 lens; 1/2500 sec at f4; ISO 1250.**

## Snowbird

**Edwin Sahlin**

SWEDEN

Cheese and sausage are what Siberian jays like – so Edwin discovered on a skiing holiday with his family in northern Sweden. Whenever they stopped for lunch, he would photograph the birds that gathered in hope of scraps. On this occasion, while his family ate their sandwiches, Edwin dug a pit in the snow deep enough to climb into. He scattered titbits of food around the edge and then waited. To his delight, the jays flew right over him, allowing him to photograph them from below and capture the full rusty colours of their undersides more clearly than he had dared hope.

**Nikon D7000 + 35mm f1.8 lens; 1/2000 sec at f7.1 (-0.7 e/v); ISO 320; pop-up flash.**

# The TimeLapse Award

This is given to a sequence of still images lasting between 45 and 90 seconds that tells a story, captures a dramatic moment or paints a creative tableau.

www.nhm.ac.uk/winter-endings

**WINNER**

## Winter endings
### Paul Klaver

THE NETHERLANDS

One winter afternoon in the Dutch Oostvaardersplassen Nature Reserve, Paul discovered the still-warm body of a red deer doe. 'To capture her fading spirit' he photographed her eye. Then decided to let the camera run overnight. It caught shadows of reeds and a spark of light as the eye caught the moon before freezing solid. He was inspired to take more time-lapse images in the reserve: snow shrouding a kingfisher in white, a frozen tree in starlight. The result is a moving tribute to natural rhythms, revealing scenes that otherwise would be impossible to witness.

**Canon EOS 5D Mark II + range of lenses (14 to 100mm); different interval and dissolve times (1 to 30 seconds); raw files processed in After Effects, sequence edited in Premiere Pro.**

## Migration in motion
### Will and Matt Burrard-Lucas
UNITED KINGDOM

The world's largest migration of land mammals is that of more than 1.5 million wildebeest, which move between the Serengeti in Tanzania and the Maasai Mara in Kenya each year. Their journey to find fresh grazing involves a 3,000-kilometre (1,865-mile) round trip that takes in the Mara River, where at times some 10,000 wildebeest cross in just half an hour. Will and his brother Matt knew that timelapse could convey the dynamics of the famous Mara crossing in a way that neither still images nor film could. For five days, they patrolled the river to see where the wildebeest were massing, and they set up their cameras at likely crossing points. The results revealed normally indiscernible patterns, including the rippling ribbons of swimming animals wafted downstream by the current.

Canon EOS-1D Mark III + 16–35mm f2.8, 24–70mm f2.8, 70–200mm f2.8 lenses; 1–3 frames per sec; tripods; QuickTime Pro to assemble, Final Cut Pro to output.

www.nhm.ac.uk/migration-motion

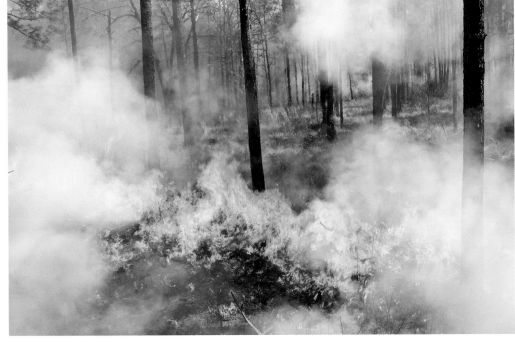

www.nhm.ac.uk/fire-tree

## The fire tree
### Rich Reid
USA

Two centuries of timber cutting and agricultural use have reduced the old-growth longleaf pine wilderness in the Moody Forest Natural Area in Georgia, USA, to a fraction of its original range. Longleaf pine forests are home to many threatened species, most adapted to the natural cycle of lightning-caused burns. The pine itself is not only fire resistant, but its seeds need fire to germinate. Today, fires are started deliberately to achieve this. Rich designed a tree-mounted housing that would withstand the fire. The fire-fighters helped him by predicting and scripting the burn around his three cameras so that he could safely change the sequence intervals before, during and after the prescribed burn. The cameras survived, though their hoods melted.

Nikon D7000 + 28mm f2 lens; customized Pelican case + hood; three different interval and dissolve times; After Effects to assemble, Premiere Pro to output.

# Index of Photographers

**118**
**Karine Aigner**
USA
karine_aigner@yahoo.com
www.karineaigner.com

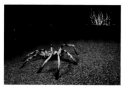

**56**
**Javier Aznar González de Rueda**
SPAIN
javiaznar@hotmail.com
www.javier-aznar-photography.com

**50**
**Ary Bassous**
BRAZIL
ary.bassous@uol.com.br
www.tyba.com.br
Agent
www.tyba.com.br

**150**
**Joshua Burch**
UK
joshua@sburch.f2s.com
www.joshuaburch.co.uk

**100**
**Bernardo Cesare**
ITALY
bernardo.cesare@unipd.it
www.microckscopica.org

**142**
**Marc Albiac**
SPAIN
marcalbiac@gmail.com
www.marcalbiac.blogspot.com.es

**140**
**Daniel Back**
UK
karen.back@artillery.co.uk

**155**
**Will and Matt Burrard-Lucas**
UK
will@burrard-lucas.com
www.burrard-lucas.com

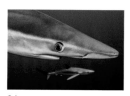

**94**
**Jordi Chias Pujol**
SPAIN
jordi@uwaterphoto.com
www.uwaterphoto.com
Agent
www.naturepl.com

**84**
**Dana Allen**
USA
photosafari@zol.co.zw
www.photosafari-africa.net

**38**
**Alexander Badyaev**
RUSSIA/USA
abadyaev@email.arizona.edu
www.tenbestphotos.com

**138, 139**
**Leon Bohlmann**
GERMANY
leonbohlmann@t-online.de
www.fotografen-mecklenburg.de

**85**
**Alessandro Carboni**
ITALY
alecarbo@tiscali.it
www.alessandrocarboni.com
Agent
www.photofvg.it

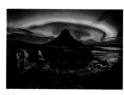

**80**
**David Clapp**
UK
info@davidclapp.co.uk
www.davidclapp.co.uk

**61**
**Ingo Arndt**
GERMANY
ingo@ingoarndt.com
www.ingoarndt.com
Agents
www.mindenpictures.com
www.naturepl.com

**98**
**Patrik Bartuska**
CZECH REPUBLIC
patrik@patrikbartuska.com
www.patrikbartuska.com

**42**
**Łukasz Bożycki**
POLAND
bozycki@gmail.com
www.bozycki.pl
Agent
kontakt@bozycki.pl

**34**
**Pedro Carrillo**
SPAIN
info@pedrocarrillo.net
www.pedrocarrillo.net

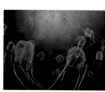

**88**
**Geo Cloete**
SOUTH AFRICA
geo@wwx.co.za

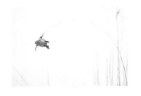

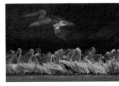
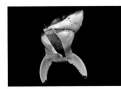
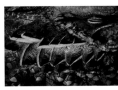

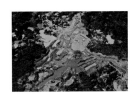

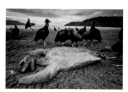

**72**
**Nick Hawkins**
CANADA
nickjameshawkins@gmail.com
www.njhawkins.com

**114**
**Ian Johnson**
SOUTH AFRICA
ian@ijwild.com
www.ijwild.com

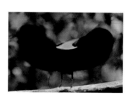

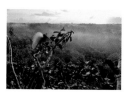

**35**
**Gavin Leane**
IRELAND
leanegreen@gmail.com
www.gavinleanephotography.com

**64**
**Hannes Lochner**
SOUTH AFRICA
hannes@lochnerphoto.com
www.hanneslochner.com

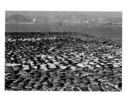

**120**
**Paul Hilton**
UK/AUSTRALIA
mail@paulhiltonphotography.com
www.paulhiltonphotography.com

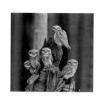

**147**
**Sitara Karthikeyan**
INDIA
sitarakarthikeyan@yahoo.in

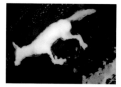

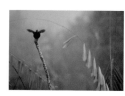

**106**
**Andrew Lee**
USA
dr.ajlee@gmail.com
http://ajlfoto.com

**108**
**Bryan Lowry**
USA
bryanLowry@lavapix.com
www.lavapix.com

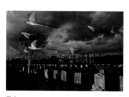

**74**
**Sam Hobson**
UK
samhobsonphoto@gmail.com
www.samhobson.co.uk

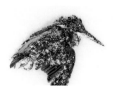

**154**
**Paul Klaver**
THE NETHERLANDS
info@pklaver.com
www.pklaver.com

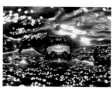

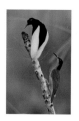

**148**
**Anton Lilja**
SWEDEN
antonlilja@live.se

**102**
**David Maitland**
UK
dpmaitland@gmail.com
www.davidmaitland.com
**Agents**
www.gettyimages.com
www.naturepl.com

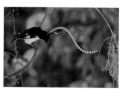

**44**
**David Lloyd**
NEW ZEALAND/UK
david@davidlloyd.net
www.davidlloyd.net

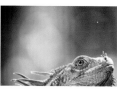

**145**
**Will Jenkins**
UK
sjhowling@yahoo.co.uk

**16, 18, 20, 21, 22, 23**
**Tim Laman**
USA
tim@timlaman.com
www.timlaman.com

**30, 52**
**Herfried Marek**
AUSTRIA
herfried.marek@aon.at
www.herfriedmarek.com

**66**
**Bence Máté**
HUNGARY
bence@matebence.hu
www.matebence.hu

**144**
**Marc Montes**
SPAIN
malluc@hotmail.com
www.javimontes.com

**76**
**Francisco Negroni**
CHILE
fjnegroni@gmail.com
www.southpressagency.com

**141**
**Leon Petrinos**
GREECE
leon@petrinos.com
**Agent**
www.naturepl.com

**153**
**Edwin Sahlin**
SWEDEN
edwin97@comhem.se
www.edwinphoto.se

**146**
**Skye Meaker**
SOUTH AFRICA
emeaker@webstorm.co.za

**92**
**Adriano Morettin**
ITALY
morettin_adriano@alice.it

**65**
**Sergio Pucci**
COSTA RICA
sergio@pucci.cr
www.pucci.cr

**46**
**Simone Sbaraglia**
ITALY
simone@simonesbaraglia.com
www.simonesbaraglia.com

**96**
**Fabien Michenet**
FRANCE
fmichenet@yahoo.fr

**57**
**Alexander Mustard**
UK
alex@amustard.com
www.amustard.com

**12, 32, 40**
**Michael 'Nick' Nichols**
USA
nickngs@mac.com
michaelnicknichols.com
**Agent**
www.natgeocreative.com

**155**
**Rich Reid**
USA
rich@richreidphotography.com
www.richreidphotography.com

**48, 90**
**Brian Skerry**
USA
brian@brianskerry.com
www.brianskerry.com

**146**
**Tristan Moës**
BELGIUM
trimoes@gmail.com
philippe.moes@skynet.be
www.photos-moes.be

**60**
**Ewald Neffe**
AUSTRIA
ewald.neffe@aon.at
www.ewaldneffe.com

**136**
**Carlos Perez Naval**
SPAIN
enavalsu@gmail.com
www.carlospereznaval.wordpress.com

**58**
**Raviprakash S S**
INDIA
raviprakash.ss@gmail.com
www.raviprakash.co.in

**53**
**Matthew Smith**
UK/AUSTRALIA
mostin76@gmail.com
www.mattysmithphoto.com

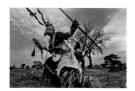

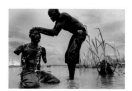

**122, 124, 125, 126, 127**
**Brent Stirton**
SOUTH AFRICA
brentstirton@gmail.com
www.brentstirton.com
Agent
www.gettyimages.com

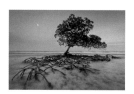

**26**
**Mac Stone**
USA
macstonephoto@gmail.com
www.macstonephoto.com

**82**
**Hans Strand**
SWEDEN
strandphoto@telia.com
www.hansstrand.com

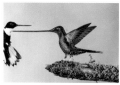

**28**
**Silvio Tavolaro**
ITALY
silvio.tav@tiscali.it
www.silviotavolaro.com

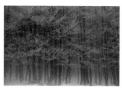

**73**
**Jan van der Greef**
THE NETHERLANDS
greef313@planet.nl
www.insightintonature.com

**78, 79**
**Paul van Schalkwyk**
NAMIBIA
(deceased)
Agent
Elmarie van Rensburg
elmarie@mac.com.na

**24**
**Christian Vizl**
MEXICO
cvizl72@gmail.com
www.christianvizl.com

**112**
**Steve Winter**
USA
stevewinterphoto@mac.com
www.stevewinterphoto.com
Agent
www.natgeocreative.com

**86**
**Indra Swari Wonowidjojo**
INDONESIA
indraswariw@gmail.com
www.indraswariw.com

**29**
**Minghui Yuan**
CHINA
ymh2zml@163.com
www.weibo.com/u/3969469253

**152**
**Ingo Zahlheimer**
GERMANY
ingo@zahlheimer.eu
www.ingozahlheimer-photography.de